New Ways in
COLLAGE

New Ways in
COLLAGE

Mary Jane Mayer and Mary Webb

VNR VAN NOSTRAND REINHOLD COMPANY
NEW YORK CINCINNATI TORONTO LONDON MELBOURNE

Van Nostrand Reinhold Company Regional Offices:
New York Cincinnati Chicago Millbrae Dallas

Van Nostrand Reinhold Company International Offices:
London Toronto Melbourne

Published by Van Nostrand Reinhold Company
450 West 33rd Street, New York, N.Y. 10001

Published simultaneously in Canada by
Van Nostrand Reinhold Ltd.

16 15 14 13 12 11 10 9 8 7 6 5 4 3 2 1

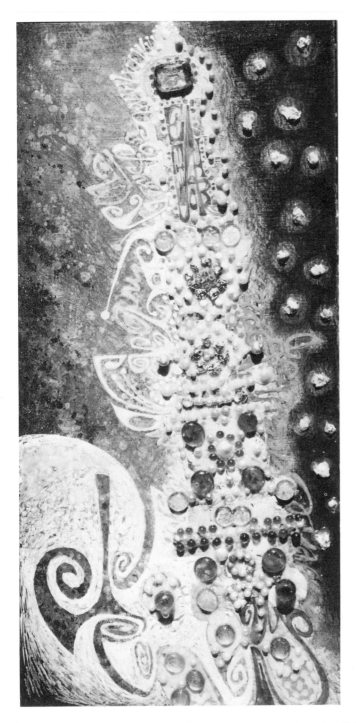

Fog on the Edge of the Lighthouse Tower, Irene Lagorio. Embedded objects and acrylic paint, 12 by 26 inches. (See detail on page 85.)

Hawaiian Armour, John Kjargaard. Rice paper and acrylic paint. (See Color Plate 15.)

Acknowledgments

The authors wish to thank William Webb, who took the photographs used throughout this book, for his generous advice and assistance. We also wish to thank Barbara Klinger, our editor. We are grateful for the professionalism she brought to her craft.

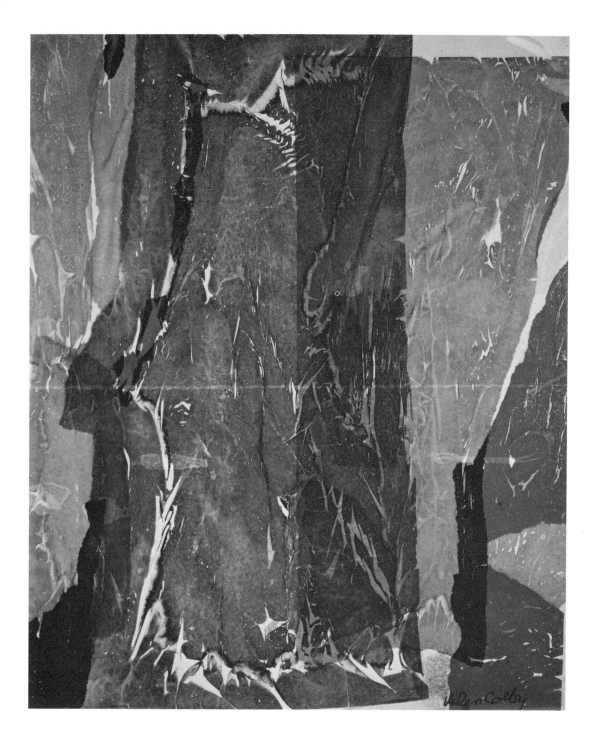

Blue Cliffs, Helen Colby. Dye transfer on X-ray film, 13 by 16 inches.

Contents

There are thirty-six color plates appearing in two fold-out sections. The first section is opposite page 56, and the second is opposite page 80.

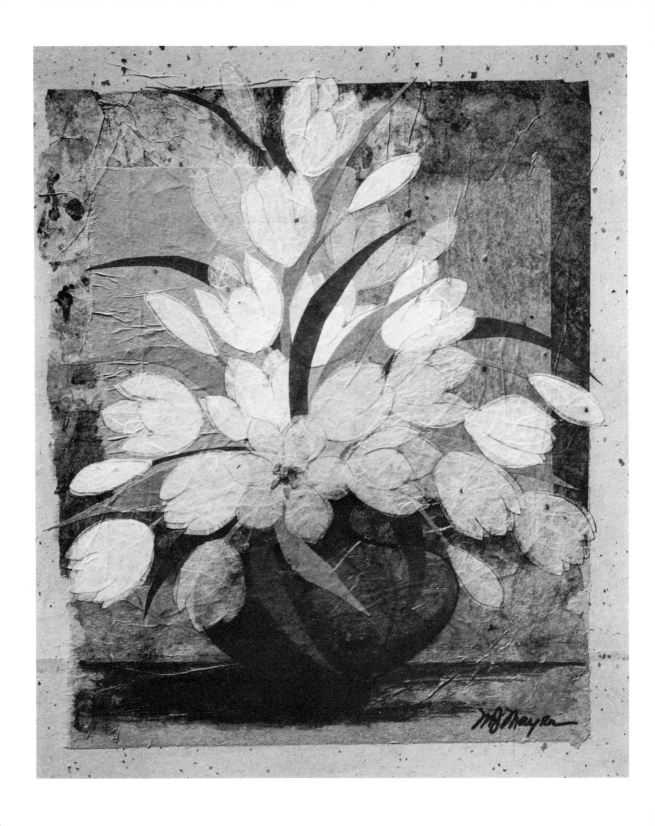

10

Preface

Anyone can make a collage! Our book is designed to make the achievement even easier. Anticipating a few pitfalls that might cause the beginner to stumble, we have outlined in considerable detail the procedures involved in making a collage.

The first chapters deal with the basic tools and materials that are required to make a simple, Japanese rice-paper collage and show step-by-step methods for making such a collage. The subject matter and style of these rice-paper collages are simple enough so that even the most inexperienced beginner will find no difficulty in emulating them. We have chosen to stress the use of rice paper because the results are unusually attractive and because the papers lend themselves to numerous artistic and decorative styles. A brief account of how these collages may be mass produced is included. We also go into the more difficult matter of "inspiration."

The later chapters of the book illustrate the work of several contemporary artists in the collage medium. These examples will show how, once the mastery of a basic technique is acquired, one may branch out experimentally in a number of directions. Few media have proven to offer such a variety of approaches as does collage; and, historically, collage has been perhaps the most fertile ground for the growth of the most advanced and imaginative techniques in the art of our time: assemblage, junk sculpture, happenings, décollage, etc.

Experimentation is really the essence of collage, and we hope that, once our readers are secure in their ability to handle the basic elements, the experience gained in the disciplined creation of a simple collage will encourage each one to exciting adventures.

Fig. 1. *Tulips,* Mary Jane Mayer. Rice-paper collage, 20 by 28 inches.

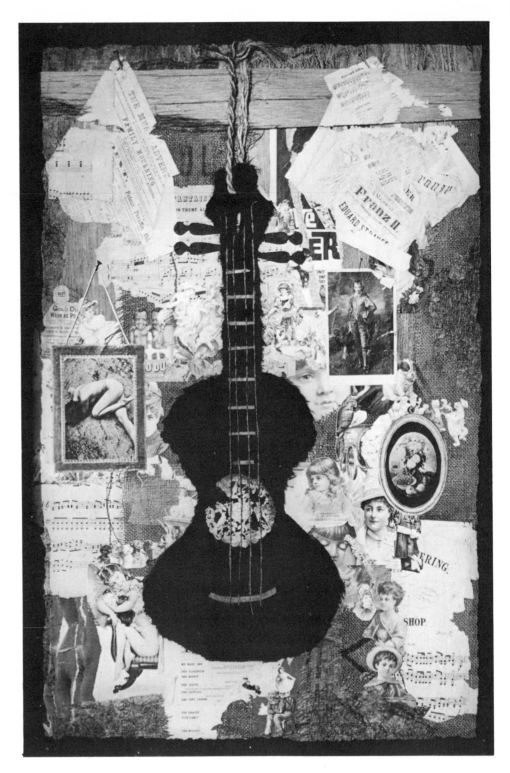

Fig. 2. *Nostalgia*, Mary Jane
Mayer. A collection of memor-
abilia gathered into a collage
(20 by 30 inches).

1. Materials and Tools

The Support

A collage can be built upon almost any firm surface. The following materials, however, offer trouble-free bases and can be recommended to the beginner.

Masonite. A pressed-wood board. Use the untempered board, obtainable at all lumberyards, as it is softer and accepts pins more readily. In addition, it is somewhat cheaper than tempered boards. Thickness should be appropriate to the size of the collage; ⅛ inch is sufficient for most small collages. There is a tendency for large pieces of Masonite to curl after the collage is dry. To some extent, this can be avoided by the use of thicker boards. A better solution, however, is to size both sides of the board; if this is done, thinner board may be used.

Particle board. An inexpensive board made from sawdust and small chips of wood; usually available at lumberyards in ½-inch and ¾-inch thicknesses. It accepts pins readily and lends itself to both framed and unframed collages. In the latter case, the edges of the board may be covered by wrapping the background papers around them. If conventional framing is desired, a light molding can be readily nailed to the edge of the board.

Plywood. Thicknesses of from ⅛ to 1 inch can be obtained. A surface of Philippine mahogany is smooth and accepts pins readily. In general, only uniform surfaces should be used, and "shop" grades or veneer surfaces with prominent grain (such as rotary-cut Douglas fir) should be avoided except where those features are going to become an actual part of the collage. The core of the plywood is not important, provided it is sufficiently sturdy and free of curl to give the collage adequate support and flatness.

Canvas. Artist-grade canvas is the deluxe support for any collage, but considerably more expensive than board. Collage can be readily applied to any stretched canvas, or to canvas glued to boards. It is the ideal support where combined techniques—such as collage on oil painting, or acrylic over a collage base—are contemplated.

Corrugated paper. Of the commonly available supports, this has the least to recommend it. It is an inexpensive support, however, and this makes it useful for experiments where permanence is of no importance. It has a bad tendency to curl, and should receive sizing on both sides.

Papers

Japanese rice papers, available in a variety of textures, weights, and colors, lend themselves to the making of beautiful collages. They are a delight to handle, and many are of such great intrinsic beauty, they are in themselves inspiring. Serious workers would do well to accumulate a collection of these papers and experiment with the multitude of effects that can be realized with them. These papers are now sold in most art supply stores, and some paper dealers carry a limited selection. For the purposes of our step-by-step demonstrations, at least four readily available rice papers should be on hand.

The names used for the many varieties of handmade Japanese papers vary considerably, according to the Japanese makers and the American distributors. However, most art supply dealers are now stocking papers from several sources and

will have equivalent papers to almost anything you might ask for. A list of some of the most useful rice papers for collage work follows:

Ungeishi. A thin, velvety sheet with clearly visible strands of fiber. Ideal for déchirage flowers.

Natsume. Like *ungeishi* but heavier and less glossy; it is also ideal for flowers.

Moriki. An opaque sheet that comes in a variety of colors. Very useful for backgrounds, opaque flowers, vases, or other objects.

Ogura. A sheet with rough-textured surface. Ideal for backgrounds, especially where weight and texture is desired.

Kinwashi. Similar to *ogura,* but lighter in weight and with a finer texture.

Kaji. A heavy, leathery paper; opaque and ideal for use as leaves. Several colors available.

Unryu. A thin, warm-colored, translucent paper with moderately heavy fibers giving it texture and substance.

Yamato. A natural-colored, thin tissue containing particles of tan-colored bark and fiber. Useful for backgrounds.

Chiri. Slightly heavier than *yamato,* with somewhat larger flakes of bark.

Sugikawa. A thin, brownish paper with a fine, fibered texture; useful for flower stems, trees, etc.

Wakasa. Heavy, rather plain paper for backgrounds.

Chukin, Shin-Chukin, and **Tea Chest Paper.** Gold and silver papers with a wide variety of designs

and surfaces; they have many uses for vases, backgrounds, etc.

Taiten. A useful paper for flowers and leaves as it has a subtle, fiber texture. Available in several colors and in both lightweight and medium-weight sheets.

Tenjyo. A very thin sheet, almost to the point of vanishing; indeed it is full of tiny holes. Gives the effect of lace.

We do urge that the basis of your paper collection be the Japanese rice papers because of their preeminent suitability for the process. However, once you begin to make collages in earnest you will see the necessity of accumulating a large variety of papers. A list of possibilities is almost endless, but here are a few suggestions: (**1**) Printed decorative papers. (**2**) Wall paper. (Your local dealer may be able to supply scraps.) (**3**) Gift wrapping. (**4**) Pages of magazine illustrations. Coated and glazed papers present special problems in handling, but familiarity with our basic methods will suggest the approach to use in managing these more difficult papers. (**5**) Paper napkins and towels. Paper napkin colors are practically indestructible; where lightfastness is important, remember this. (**6**) Photographs. Photographic paper is rather stable dimensionally and works into a collage easily provided the paper is dampened first. (**7**) Tissue and construction papers, available in art supply shops. (**8**) Posters and billboard papers. (**9**) Candy wrappers, cigarette packages, labels from wine bottles, discarded book jackets.

These are just a few suggestions. Once you have become involved with collage, no paper will ever again escape your foraging eye! As your proficiency increases, and as you begin to develop your own idiomatic approach to collage, you may also want to collect other materials, such as rags, foils, veneers, leather, glass, films, etc. There is no limit to potential materials.

Adhesives

In making collages with mixed media, the chemical and physical properties of all the materials, including the adhesives, must be compatible with each other. While oil paint can be applied over a dried acrylic paint, for example, the reverse application of acrylic over oil may well lead to a disaster. Thus, in combining collage elements with any acrylic painting, either when attaching papers to a painted surface or when painting over a collage base, the ideal adhesive is acrylic polymer varnish (or medium). This can be used undiluted or diluted in the ratio of two parts of varnish to one part water, depending on the consistency desired. Some artists prefer to use a polyvinyl-acetate emulsion (PVA) glue, such as Elmer's or Wilhold, diluted one-to-one with water. These PVA glues are compatible with acrylic emulsions as long as the two substances are not mixed together in a liquid state but are applied in separate layers, with one being allowed to dry before the second is used. In a situation where only oil-based colors are to be used, wheat paste will provide better adhesion for the collage elements than either polymer emulsion or polyvinyl-acetate glue.

When no heavy-bodied pigments, such as acrylics or oils, are to be combined with the papers, relatively light, easily worked adhesives are best. In our demonstration projects, we suggest the use of wheat paste or cellulose paste (methyl cellulose), both of which are obtainable through dealers in wallpaper.

There are some special advantages in the use of cellulose paste. It is non-staining, dries rapidly, and does not decompose in either a dry or liquid state. Wheat paste, on the other hand, while having somewhat better adhesive properties, must be used promptly because it ferments and becomes foul on standing. Also, it can attract weevils in the dry state.

Cellulose paste dissolves readily without lumps, washes off easily in water, and is transparent

when dry. Used with the Japanese rice papers, it preserves the exquisite translucency for which these papers are noted.

Glazes

We recommend applying a thin glaze coating to the completed collage. This will protect it and inhibit discoloration, and also render it waterproof so that it may be cleaned simply by wiping it off with a clean, damp cloth. Several products are suitable. Without doubt the best of these is the acrylic polymer varnishes sold in art supply stores. These varnishes are manufactured to artists' standards of permanence and reliability. They are of slightly alkaline reaction, which favors preservation of the delicate papers. For glazing, these varnishes can be thinned to the desired consistency with water. A ratio of two parts of varnish to one part of water is frequently used.

A second choice would be the clear vinyl exterior varnishes which are used to cover natural wood and are obtainable in paint stores. This product should be diluted in the ratio of about one part varnish to one part water for best results. A third choice, and the most economical, is white PVA glue (Elmer's, Wilhold, etc.) diluted with about three parts of water to each part of glue. Unfortunately, some of these white glues contain plasticizers of acidic reaction, which makes their aging unpredictable.

All of these products are milky when first applied, but they dry to complete transparency and, a few days after application, cure to a completely waterproof film.

Colorants

Often it is impossible to find a paper of the desired color and it then becomes necessary to dye or otherwise color a few sheets of paper. Also, special effects, in which the coloring agents are applied to the paper irregularly or in varied patterns, can be useful in many collages.

For these purposes, it is suggested that you obtain a small supply of various dyes and a selection of dry, transparent pigments, as well as some other possible colorants mentioned in the next paragraphs. Large quantities are not needed, as all the suggested colorants are strong and go very far indeed when applied to rice paper by our methods.

In acquiring your collection of coloring agents, remember the important difference between dyes and pigments. Dyes are substances that form chemical bonds with certain fibers. They are usually soluble in water, but some are soluble only in alcohol, or mineral spirits or other vehicles. When properly applied, they migrate from the vehicle into the fiber, penetrating and coloring the fiber more or less strongly, depending upon the affinity of the particular dyestuff for the particular fiber.

Pigments, on the other hand, are insoluble colored particles, usually ground very finely, and they do not form chemical bonds with fibers. Instead, they are usually suspended in a thick medium, such as oil, acrylic emulsion, or gum solutions, and they color fibers simply by coating them with thin layers of colored particles. Unlike dyes, they do not penetrate the fiber and they remain in place because the medium they are dispersed in adheres upon drying.

Pigments and dyes are both used in coloring papers for collage, but the behavior of each is quite different, as are the results achieved by each.

Some of the most useful dyes are becoming increasingly difficult to find, especially in small quantities.* Among these are the *aniline wood stains,* which are dry powders, some of which are

*One source for all dyes and stains in small quantities: The Ångstrom Unit; P.O. Box 528; Monterey, California 93940.

soluble in water, others in alcohol, and others in turpentine or mineral spirits (the last category is sometimes called oil-soluble). It is an excellent idea to get a few stains that are soluble in the different media, as interesting effects can be achieved when incompatible media, each carrying different colors, are floated on the surface of water and begin to interact with each other (see page 47). Unfortunately, these wood stains are not available in a complete palette of colors, being mostly confined to colors suitable for staining wood. (Liquid transparent watercolors are also aniline dyes and are available in many colors, but these have more of a tendency to bleed.) Look for the dry, aniline wood stains in large paint stores.

All-purpose household dyes, intended for dyeing fabrics and generally of fashionable, rather subdued colors, can also be used. These are not recommended, however, unless you are prepared to cope with their tendency to bleed out into the adhesive when you are pasting down the papers, not only ruining the color in the paper, but staining the adhesive as well. However, when you understand what is going to happen with these dyes (chapter 4), you can no doubt figure out ways to use them which will enhance the effect you are trying to achieve. We suggest that, for beginning work, you avoid these dyes.

Dyes now sold by art supply dealers for making batiks offer a wide range of bright colors which can be adapted to coloring paper. These, too, although they are sometimes called cold-water dyes, are really intended for bonding to textile fibers at elevated (lukewarm) temperatures and, when applied to paper, they are not entirely controllable; yet they work better than ordinary all-purpose dyes.

Other dry dyestuffs (most of them rather difficult to obtain except through special suppliers and in large quantities) have some limited uses in collage work. Most important of these is a group of so-called "direct dyes," which are primarily used for dyeing textile fibers of vegetable origin, such as cotton and linen. Although such dyes require an elevated temperature for best results and there is some tendency for the colors to bleed when used with paper fibers, the color range is very wide, with many very bright colors.

Less useful are the "acid" colors, which bond chemically with fibers of animal origin, such as wool and silk. These colors do not penetrate paper fibers well, but they can be painted on after the papers have been glued down. Again, the color range is very wide and colors are brilliant. Some colors leave much to be desired in the way of permanence, however.

Cheap commercial printing papers are dyed bright colors with "basic" dyes. These are usually too fugitive, however, to use in collage.

Also avoid getting the vat colors (made water-soluble by chemical reduction) sometimes offered for use in tie-dye. These dyestuffs have a complicated chemistry not suitable for the spontaneous effects we try to achieve with our rice papers. Food colors are also not suitable. These dyes are quite fugitive and bleed so freely as to be practically uncontrollable.

Dry, transparent pigments, finely ground for artists' use, can be dispersed in water, very thin drying oils (such as linseed or poppy seed oil), varnishes, alcohol, or gum arabic solutions, and will react in each of these somewhat differently. The pigments offer the maximum in permanence, and come in brilliant colors. Semi-transparent or opaque pigments can be used for bold effects, but we suggest you postpone using these until you are working with assurance and have experimented with the more transparent pigments.

Ordinary watercolors and acrylic paints are dry pigments already dispersed in aqueous vehicles, and they offer no advantages over the dry pigments, except that they are possibly more readily available. They require considerable thinning in order to get the kind of thin films of color we need for our processes.

For the finishing touches on a rice-paper collage, waterproof, transparent drawing inks, such as Pelikan or Higgins, are excellent. These inks, available in many colors, are too expensive for general use in coloring large sheets of paper, but one small bottle of any desired color will last a very long time when used for touch-up work or for coloring rather small areas.

Miscellaneous Supplies

Work areas should be covered with newspaper as protection against spilled paste and coloring agents. Collage-making isn't exactly a fastidious process and some mopping up will be necessary from time to time. Old rags or paper towels will be useful.

A supply of straight pins, preferably those with large, glass bead heads, will be needed for pinning the collage together before it is pasted down.

Equipment

A very minimum of equipment is needed to make a collage. Here is a basic list:

A large **tray** for coloring sheets of paper. A photographic tray, about 16 by 20 inches, is ideal.

A flat **brush,** about 3 inches wide, for sizing and glazing. A house painter's brush is quite adequate for this purpose.

A 1½-inch, flat-stroke **brush** for applying paste to small pieces of paper.

A minimum of three round, **watercolor brushes** in assorted sizes.

Scissors, medium-size for cutting paper.

A cellulose or viscose **sponge.**

Small ceramic, plastic, or stainless steel **bowl.**

Forceps, helpful in picking up small pieces of paper.

An upright **easel.**

A couple of **glass jars** for water.

Fig. 3. (Opposite page) *Poppies,* Mary Jane Mayer. Completed collage of various rice papers torn, cut, and pasted according to basic method (24 by 32 inches).

2. A Basic Method

The basic method described in this chapter allows the collagist to become familiar with his materials and with the effects they can create. It also introduces simple compositional problems and shows how to create an illusion of depth when arranging and pasting the elements of the design.

Because in this method the elements are first pinned to the prepared support, there is the opportunity to experiment freely not only with the compositional arrangement but with the initial choice of elements as well. Nothing is irrevocable until the composition has been judged satisfactory and the decision is made to actually paste the elements down. In addition, you will see that compositions may be altered and improved even while pasting is in progress, and that final touches may be added after pasting has been completed.

In describing the basic method we have given

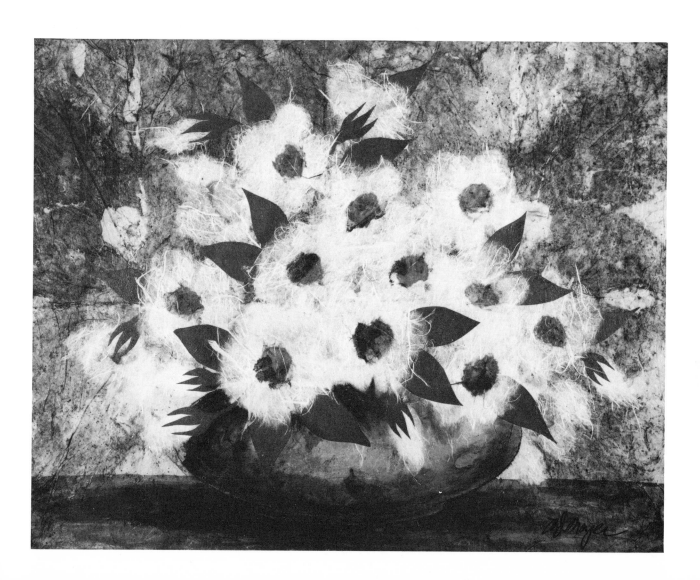

twelve steps and have illustrated how each step was realized by detailing a single rice-paper collage in all its stages, from the unsized support to the completed composition. These steps, although not inflexible, will provide a sound technical foundation for those unfamiliar with these particular collage materials or procedures. As experience and proficiency in handling both are increased, educated departures from the basic method will probably follow naturally and will lead to greater originality in your own work.

Step 1. Determine the kind of support to use, and have it cut to the correct size. Large collages should be made on heavier boards, up to ¾-inch thick particle board for collages over 4 feet square, and where maximum flatness is required. For quick experiments use corrugated boards. Masonite hardboard, ¼-inch thick, is the most generally suitable support.

Working large is a genuine virtue in rice-paper collage, because handling small pieces of very delicate papers can become a real problem, and because the textural effects of the handsome Japanese papers do not show up to advantage in forms of too small a size.

In our example, we chose untempered Masonite hardboard of ¼-inch thickness, smooth on one side only, and had it cut to 24 by 32 inches.

Step 2. Assemble the papers that will be used. Here the important thing is to always have *enough,* both in variety and quantity of paper. Many of these may not be used, but an abundance of things to choose from speeds the work and stimulates the imagination. It is not possible, nor would it be desirable, to have a collage so carefully planned in advance that all spontaneity in its making was lost. Each step in a collage may very well suggest another step that could not have been foreseen in advance, and a great measure of the excitement of the creative process comes from

being able to respond to each of these suggestions arising out of the work itself. Be well-prepared!

You may wish to dye some of these papers to get colors which do not come in stock, or to obtain special effects. Refer to Chapter 4 for instructions on dyeing papers.

In our example, we provided several sheets of white *natsume* for the flowers (*ungeishi* could have been used as well), large sheets of pale-yellow *chiri* for the background, and additional sheets of *chiri* in case the background texture needed enrichment. A small piece of *kaji,* in a deep green, seemed exactly right for the leaves and the bases of the flowers. Some gold, metallic wrapping paper was chosen for the vase, and a miscellany of tissue paper was on hand.

Step 3. Size the support. Sizing is a preparation of the surface of the support to make subsequent layers adhere readily. The object is to fill the pores of the support surface with a material compatible to the paste that will be used later on to fix the papers. Ideally, the same adhesive should be used for sizing as for pasting, except that the sizing solution is in a more dilute form—about the consistency of light cream.

Using a wide, flat brush, spread the sizing solution over the board in even strokes (Fig. 4). Due to the tendency of pasted papers to shrink upon drying, a thin support may curl slightly after the collage has been completed. To avoid this, both sides of a thin support should be sized, and it may also prove helpful to paste a sheet of wrapping paper to the back of the board. Depending upon the degree of absorbency the board has, additional coats of sizing may be needed after the first one has dried. A surface is adequately sized when the coating tends to stay on the surface and not be immediately absorbed. Masonite is often sufficiently sized with a single coat.

Enterprising collagists will size a fairly large

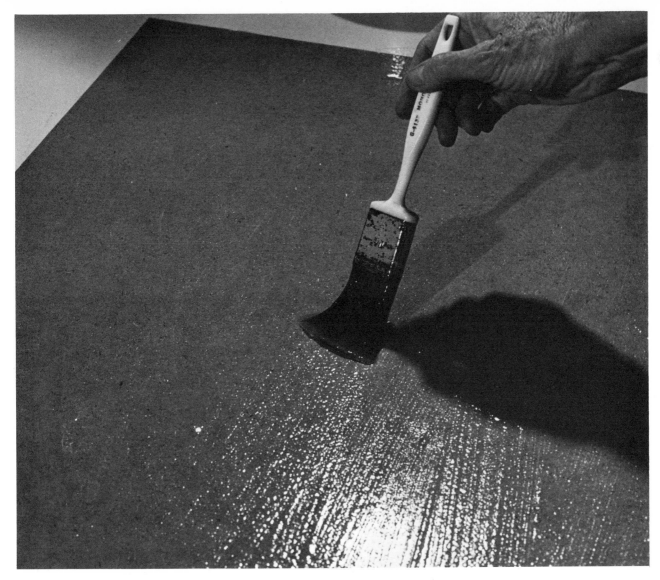

Fig. 4. A diluted coating of cellulose paste (methyl cellulose) is brushed on the support and allowed to dry.

number of boards all at the same time. Building up a little inventory of sized boards in advance of need is a real time-saver; with presized boards, you can begin at once to lay out and paste down a collage without the preliminary of waiting for the sizing coats to dry.

In our example, the sizing was made from diluted cellulose paste, and it was applied to both sides of the ¼-inch Masonite. Two coats were applied to each side, the second coat simply in order to be sure sizing was adequate. On the back side of the board, a well-dampened piece of thin, kraft wrapping paper was pasted down immediately after the application of the second sizing coat, and the paper was pressed down heavily with a roller to get maximum adherence to the rough surface. This was done in anticipation of concave

curling toward the face of the board when the finished collage was dry. The sizing coat was allowed to dry completely before we proceeded to the next step.

Step 4. The selection, and cutting or tearing, of background sheets is next. In some cases, this corresponds to a kind of "underpainting"; in other cases, it is simply to get a sheet or two of paper down on the board to enliven an otherwise plain or dull surface. In addition, different colors and shapes can be used to define the background for the main subject of the collage; shadows can be suggested, lines indicated, and tabletops defined by careful placement of different background papers. (See Color Plate 5.)

If you are going to use a single sheet to cover the entire board, you can readily cut it by laying the board down on the paper and tracing around its edge with a wet watercolor brush. The dampened area is weakened enough so that a slight pull will separate the paper at this point, and the drawing apart of the paper fibers creates a delicate edge. This technique, *déchirage,* is a very useful one in rice-paper collage.

In backgrounds, the *déchirage* edge is usually preferred, as it causes the line to be subdued and to recede, giving the illusion of being *behind* any form having the harder line of cut paper *(découpage).* In any interplay of these two kinds of edges, such as in a landscape, the sharp-edged forms will always tend to appear up front and closer than the torn-edged forms.

Fig. 5. A fresh coat of undiluted paste is applied to the board, and while it is still wet, a piece of background paper (*chiri*) is carefully pressed down on the board. A viscose sponge is used to press the paper down firmly and to work any bubbles out to the edge of the board.

In our example, we tore a large piece of plain, yellow *chiri,* following around the edge of the support with a wet watercolor brush and pulling the paper apart at the wet line. Since we were not seeking to achieve any dimensional effects with the background, but were merely trying to render interesting an otherwise plain background, we decided to use an overlay of irregularly dyed *unryu. Unryu* is a translucent paper with enough

fiber throughout to add the subtle touch of substance and texture to the background that was desired.

Step 5. Paste down the first sheet of background paper. This is accomplished by coating the dry support with a fresh layer of cellulose paste, prepared to a consistency somewhat heavier than that used for sizing, but not so heavy as to resist rapid brushing. The paper is then placed on the board and pressed down carefully with a viscose sponge, which is used to work any bubbles out to the edge (Fig. 5).

An additional coat of paste is applied to the background paper before the overlay or subsequent background forms are added. At this point, you will notice that the paper becomes almost transparent, its color and character very much subdued. This effect vanishes as the paper dries, and experience will teach you how much change to expect. Additional sheets used to create dimensional effects, or to suggest lines and forms in the background, can be applied one right after the other without intermediate drying if you are reasonably sure of the final effect. However, if you are unsure, you can allow the first sheet to dry, and then add additional sheets as you determine the necessity for them.

Remember that paste is used liberally, and is always applied to the board first, never to the rice paper before it is put down on the board.

In our example, after the first sheet of *chiri* was pasted down, we immediately pasted the overlay of *unryu* on top (see Fig. 8, page 25). Since *unryu* is very thin, it has a tendency to wrinkle and tear, which we did not make any serious attempt to prevent. We like the textured effect that wrinkling imparts to the final collage, and an occasional hole in an overlay can often bring about an "unintentional," added dimension. This will become more evident as you actually work with these exciting Japanese papers.

Step 6. The background is allowed to dry. Before proceeding further, review your accomplishments so far. Further changes in the background can be made now; they cannot be made so readily later on, when the main part of the composition is put down.

Once you are thoroughly familiar with the rice-paper method, you will be able to anticipate the appearance the background will have when it has dried. Such familiarity will enable you, at least with certain simple compositions, to proceed with the rest of the work immediately, pasting the main forms of the composition even while the background is still wet.

However, one of the advantages of the collage technique is that you can *pin* the various elements of the composition in place and study the effect you are getting, and then make easy adjustments and changes, before finally committing anything to paste. To do this, the background obviously must be dry. While it is drying, you can go on to the next step, cutting or tearing out the main elements of the collage.

Step 7. The papers that have been gathered are now spread out, and the various pieces are organized and "stockpiled." You will tear or cut the papers depending upon the intended use and the effect you want to achieve; you will choose papers of different degrees of translucency, and of heavier or lighter textures, according to the aim of your composition.

In our example, the fluffy texture of the *natsume* paper seemed entirely appropriate to the delicate, crinkled quality of the poppies we wished to represent. Moreover, we felt that *déchirage* edges would enhance the feeling of lightness. We tore out approximately 30 loose circles with gently scalloped edges, using a wet watercolor brush and quickly drawing the shapes freehand (Figs. 6 and 7). These circles were about 4 to 5 inches in diameter, and we prepared more of them than we

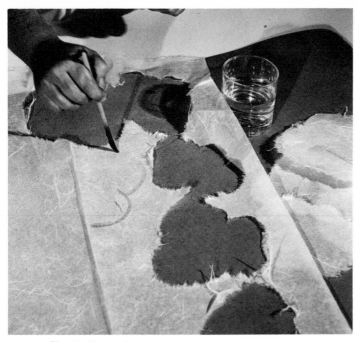

Fig. 6. The collage elements are assembled. Here *natsume* paper is being torn to make flowers by quickly drawing the outline of the form with a wet watercolor brush.

Fig. 7. After the wet outline has been drawn, the paper is immediately pulled apart along the wet line. This is the favored method of achieving *déchirage* with rice papers.

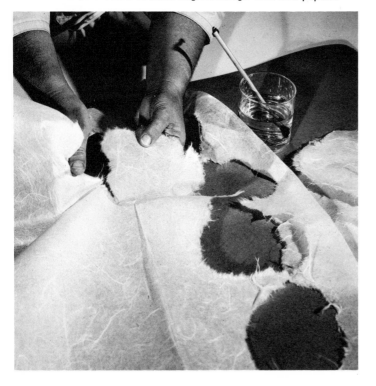

intended to use, just in case they were needed.

For the leaves, the leathery *kaji* was chosen, and each leaf was individually cut with scissors. The leaves were 3½ to 4½ inches long, and each was cut a little differently. The flower sepals and stalks were similary cut, some larger to go in the front part of the composition, some smaller to go at the back. Cutting the paper was appropriate here, because *découpage* defines the sharp lines of the leaves and stalks.

The flower centers were torn from sheets of burnt-orange, Japanese tissue; and since this paper is quite thin, we anticipated that more than one would be needed for each center.

The vase was cut from heavy gold-metallic gift wrapping paper. Symmetry was achieved by folding the paper in half and cutting out one half of the vase.

Step 8. Trial assembly is now possible. The various elements of the collage are now arranged on the support and temporarily held in position with pins. This work should be carried out with the support propped against a wall, or placed on an easel (Fig. 8), so that you can back away to study the effect you are getting. The composition should be carefully analyzed at this step in terms of the spatial effect you are trying to achieve. A series of vertical planes should be imagined, and the parts of the composition that belong in the most distant plane should be placed down first. Gradually work toward the foreground and the closest plane. By overlapping foreground shapes on those in the distant planes, and by using smaller-sized shapes for the most distant planes, a sense of distance is achieved.

The advantage of working with temporarily pinned elements is that, with no particular trouble, they may be moved about and tried in different positions. Take full advantage of this opportunity and study your work carefully to achieve the most effective arrangement possible. This is the time to go back and cut or tear additional

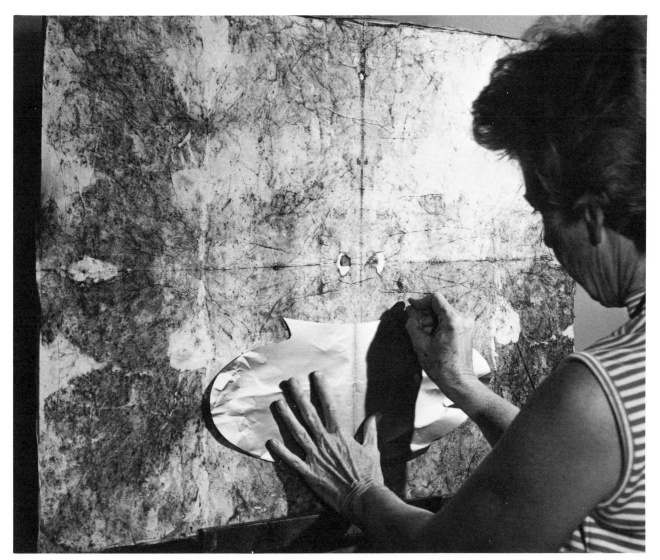

Fig. 8. When the background papers have dried, the board is placed on an easel, so that the assembly of the collage can be studied from a distance. Here, gold-metallic wrapping paper, cut in the shape of a vase, is pinned to the support. Notice that part of the overlay sheet, a very thin piece of *unryu* used on the *chiri* background, tore in spots as it was being pasted down. No attempt was made to restore or repair the holes, as it was felt these accidents contributed to the irregular effect sought for the background.

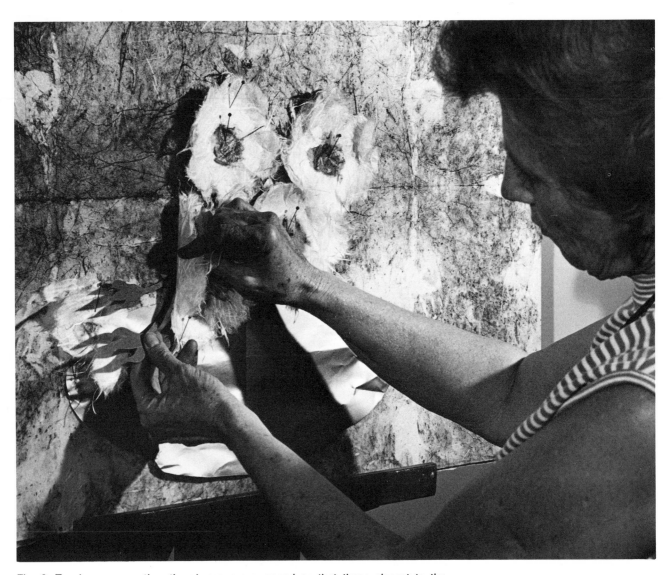

Fig. 9. To show perspective, the shapes are arranged so that those closest to the foreground overlap those in the background. Some flowers are shown turned toward the rear of the vase.

26

pieces of paper if you find that desirable. It is very much more difficult to make changes or add anything once you have started pasting.

In our example, we arranged the flowers, leaves, and vase very much as if we were making a bouquet with actual flowers. In considering those flowers that would be at the *back* of the vase, we knew that only the edges of the petals would show. We realized that some flowers would be seen from their undersides or back, so these flowers were put down with the sepals and stems on top of them (Fig. 9). We progressively moved forward to the front of the bouquet, mindful each time of which plane the flowers were supposed to occupy. Studying the composition as we went along, we made occasional alterations to satisfy the sense of depth we were trying to achieve. The relationship of leaves to flowers helped greatly to establish this third dimension, and we carefully examined each element where either overlapped the other.

The rewards of some of these efforts can be studied in the lower right of our collage (see Fig. 10), where flowers can be seen partially concealed by the vase, and also toward the top, where we are seeing a flower from below and behind. Note especially the effect of the large "spray" of flowers and leaves, appearing like a single large branch, that occupies the frontmost plane. By thinking of this branch as coming up from the bowl and pointing directly at the viewer, the placement of the elements became fairly obvious. It is this kind of analysis that makes the designing of convincing forms possible. We make intuitive use of this kind of analysis all the time in everyday life; we merely need to become conscious of it and use it purposefully.

Step 9. Pasting down the collage follows when the work has been satisfactorily pinned. Using the same adhesive used for pasting down the background, proceed with the remaining elements

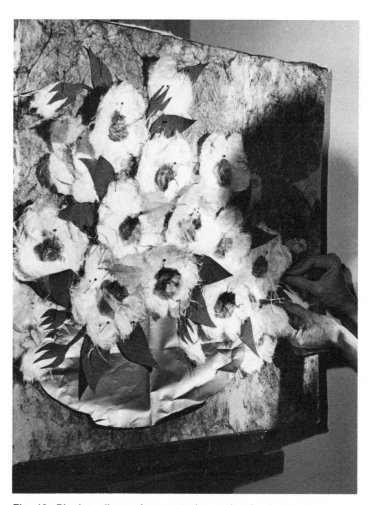

Fig. 10. Pinning allows changes to be made; the forms can be moved about until a satisfactory composition results. Flowers partially hidden by the vase or seen from behind contribute to the three-dimensional effect.

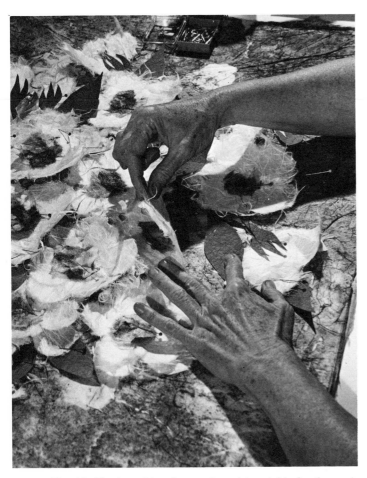

Fig. 11. The board has been returned to a table for the pasting process. Those forms that are at the top of the composition and on the lowest layer are pasted first. Overlapping forms are therefore folded back and out of the way, and held there with pins.

of the collage. Several ways of working are possible at this point. Large, simple forms can simply be unpinned and pasted. Overlapping forms, especially precisely placed ones, require a different procedure, described in the next paragraph. In working with any rice-paper form, remember that you apply paste only to the support surface. Then put the paper down on the wet paste and press it firmly into place with the brush or with the viscose sponge, eliminating any bubbles. All papers should be completely saturated with paste. Too thick a paste will be hard to handle and will not saturate the papers; if the paste is too thin, it will not adhere properly. So try to keep it as thick as is consistent with easy and rapid handling and yet not so thick that it will not quickly penetrate the papers. Rich cream is a good consistency.

The more-or-less precisely pinned, overlapping elements should be pasted down in stages, working on the layers closest to the background first, and working from the top of the composition to the bottom (Fig. 11). Move the pins enough to free one edge of the piece to be pasted, fold a portion of the form back, and apply paste to the uncovered area of the support. Then release the folded portion, push it into the paste and brush it down. Once that portion is down, the pins can be removed and the remaining portion of the same piece can be folded up from the support (but not back into the wet paste!), and paste can be applied to that uncovered area of the board. This way of folding away from the board, applying paste to the board, and then folding the paper back down (moving the pins along ahead of your work) is the way to proceed until everything is down.

As you work along, you will notice that the visual contrast of the papers is reduced, some papers becoming almost invisible. This transparency will largely disappear, but not entirely, as the collage dries. You may want to add additional "reinforcements" to thin papers, and that is where all those extra pieces we suggested will be wel-

comed. Simply pile up, as you think fit, the number of papers necessary to produce the desired tone in the finished work. The effect of adding layers of thin papers, one on top of another, is so much richer that we urge this procedure rather than choosing thicker, less transparent papers, except where special accents or complete opacity are desired.

Some of the heavier papers may be too thick to absorb the paste properly. In these instances, it is advisable to presize these pieces by giving them a special coating of paste and allowing them to dry before putting them into the collage.

In our example, pasting began at the top of the composition. The flowers were folded back singly or in small groups, and were pasted down as described (Figs. 12 and 13). We knew that the *natsume* used for the flowers would virtually disappear if all we used was a single thickness, so we had on hand extra pieces to reinforce those flowers in the main body of the arrangement. We added as many as two more layers to some of these flowers and also reinforced the centers. On the edges of the composition, we felt that transparency would be helpful, suggesting the thinness of poppy petals, so we allowed these flowers to remain a single thickness, enabling some of the background color and texture to show through.

Before doing any pasting down, we had prepared the heavy *kaji* paper we used for leaves by presizing the rear of each shape. We actually did this prior to the pinning step, simply so that we could move more rapidly in the pasting down. One could size whole sheets of paper of this kind well in advance, even before cutting out the parts.

Fig. 13. (Right) The flower is pressed into the pasted area with the paste brush and a layer of paste is added to the top of the flower, which will be overlapped by another leaf and which will have a calyx added.

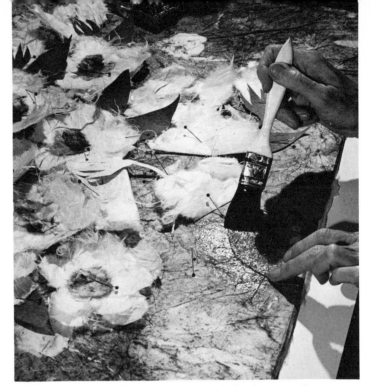

Fig. 12. (Above) The leaf under the brush is closest to the background surface. It has been presized and pasted down. The flower that overlaps this leaf is folded back while more paste is applied over the leaf, in the area the overlapping flower will occupy. No attempt need be made to confine the paste to the outline of the flower. The paste should be spread generously over an ample area to accommodate the piece being pasted down.

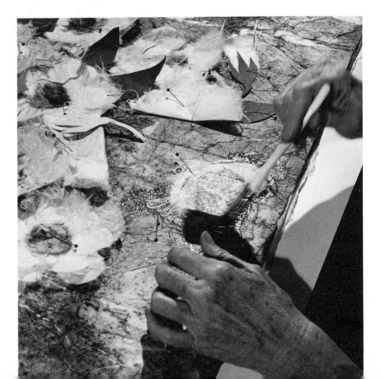

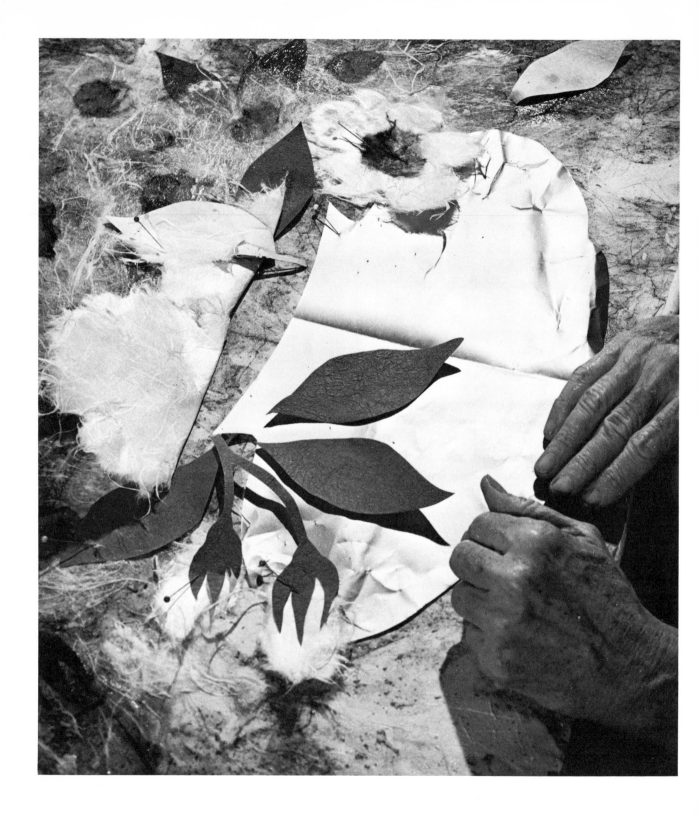

Fig. 14. (Opposite page) The top of the composition now pasted down, the vase is the next item. The flowers that will appear in front of the vase are studied so that their positions can be remembered. They are then removed while the vase is pasted down.

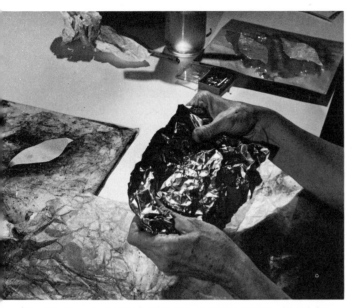

Fig. 15. It was decided that the metallic paper should be crumpled before pasting it down, to lend an antique effect and overcome the rather "brittle" look of the flat paper.

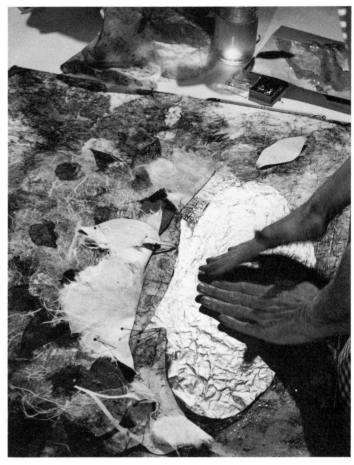

Fig. 16. The crumpled wrapping paper is laid down on a layer of paste, and pressed firmly in position. It is then decided to overlay the metallic paper with a thin sheet of *natsume*. After the overlay was in position, the flowers and leaves at the front of the composition were pasted down on top of the vase to complete the collage.

Step 10. The collage is allowed to dry. You may want to put a little reverse curl into the support at this time by drying it in a bowed position, convex side up. This is done by using a small block of wood to push up the center of the board from the rear, and placing heavy weights at the four corners on the front surface.

Step 11. A final touch-up of the collage may include drawing to emphasize forms and adjustment

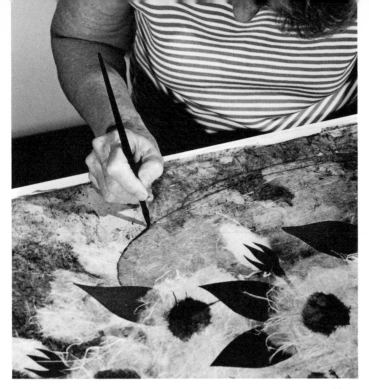

Fig. 17. The vase is outlined with diluted brown ink. Note that a few tears and holes in the overlay allows the metallic paper to show through, creating highlights and lending greater roundness to the vase.

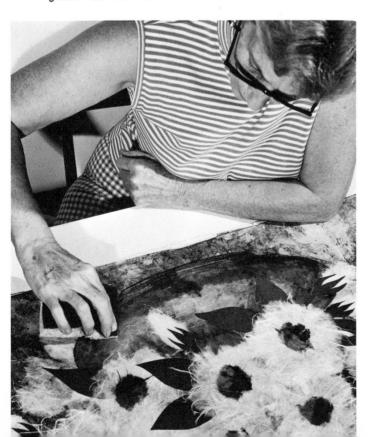

of colors (if necessary). This step involves giving some definition where it is needed to strengthen the composition and to give the work an appearance of being "finished." For this purpose, any number of dyes, transparent paints, and inks may be used. Transparency, one of the special beauties of rice-paper collage, should not be compromised. Avoid opaque pigments. Using a small watercolor brush, you can give some roundness to forms by applying a few delicate washes of color. You can also add details that are too small to be effectively managed with the papers alone.

Don't overdo this step. There may be a temptation to cover up mistakes by drawing over them. But it weakens a collage to rely heavily upon drawing. You really should only emphasize what is already implied in the forms of the papers. Nothing is more conspicuous and jarring than an attempt by drawing to make up for faulty analysis of the way the papers were put down. It is better to leave an "error" than try to cover it up.

Touch-ups should be allowed to dry before proceeding to the next step.

In our example, the vase was outlined, and washes were applied to give roundness to its form (Figs. 17 and 18). The surface on which the vase rested was indicated by means of a light-brown wash, with shadows cast by the vase put in on the surface. Accents were added to the centers of the flowers. Pelikan colored inks, diluted with some water, were used throughout.

Step 12. Glazing. When the collage is entirely dry and you have studied it thoroughly and are assured that all is well, it should be given a light glaze of diluted polymer varnish or medium, using about two parts of emulsion to one part of plain water.

The glaze is coated on quickly with a wide

Fig. 18. A light modeling wash of brown ink was added to the vase and background by dabbing with a sponge.

brush. Speed is of the essence here, to avoid any bleeding of colors. The whiteness of the emulsion dries to complete transparency. When thoroughly dry, the collage is finished. After several weeks, the coating will cure and become completely waterproof. This will enable you to clean the collage with a damp cloth, should that ever become necessary.

An Optional Exercise

The basic method set forth on the preceding pages deals with a collage of some complication. You may want to try something simpler that will give you the "feel" of the whole operation. We suggest for this purpose a kind of paper "sampler" in which there are no tricky shapes and no problems of perspective, but only the simplest kind of design problem (Figs. 19 and 20). This will free you to explore and enjoy the materials you are working with.

Select a group of about ten different papers that look compatible to you. Don't necessarily limit yourself to rice papers. Consider paper napkins, various tissues, newspaper, gift wrapping paper, and so forth. Choose colors that go well together.

Tear and cut strips of varying widths from these papers, and, allowing them to overlap, assemble them in an arrangement that gives a sense of spatial balance. Try to achieve as much interest and contrast as possible between the different paper strips. When you have obtained an arrangement you like, pin and then paste them down, as described in the basic method.

Work large. Torn papers especially should be kept large. Finish by glazing with diluted polymer emulsion.

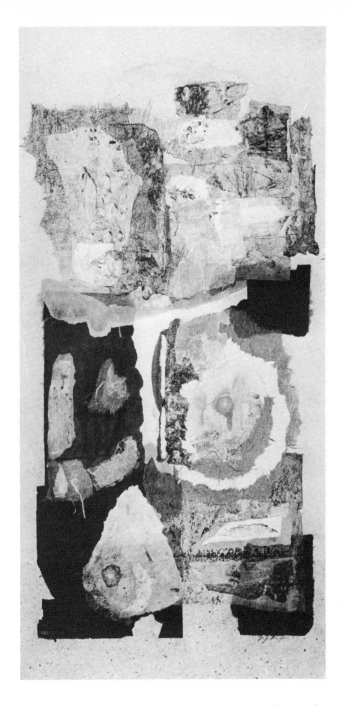

Fig. 19. *Gecko,* Mary Jane Mayer. Rice-paper collage, 12 by 36 inches. The gecko is a friendly Hawaiian lizard, abundant in the islands, and valued for its habit of eating mosquitoes. The gecko has pads on its feet, enabling it to crawl on vertical glass surfaces, or on ceilings. The lizards are often found about houses, and seem quite fearless. Mary Jane Mayer's abstraction shows a gecko in a characteristic position, running head first down a vertical wall.

Fig. 20. *Hawaiian Landscape,* Mary Jane Mayer. Rice-paper collage, 40 by 50 inches. A deceptively simple abstraction, this collage required a very careful study of space relationships, tonal values, and organization. Yet, because of its simple construction, it is an excellent exercise when trying out new papers and methods.

3. Variations in the Basic Method

Skill in handling the papers, and in anticipating how a collage will finally appear when dried, is simply a matter of repetition and experience. A couple of collages made with the basic method will create enough confidence so that you will probably wish to bypass some of the steps.

The step most readily omitted is the pinning down of the composition before pasting. Don't at-tempt this with any new composition that may have problems with placement and space relationships; but if you have made a few flower arrangements, for instance, you may feel confident enough to tackle a familiar design without pinning. On the following pages, we show a floral composition being made this way. We begin with the tearing of the background papers.

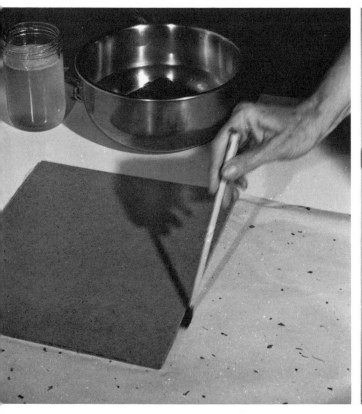

Fig. 21. A sized support is laid on a sheet of mulberry background paper. This sheet is inexpensive and is char-acterized by small chunks of brown wood bark incorporated into it. With a wet brush, the edge of the board is traced on the paper. The paper is torn by pulling it apart.

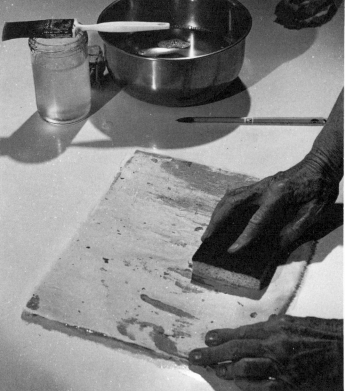

Fig. 22. A layer of paste is applied to the board and the sheet of mulberry paper is pressed into the wet paste. Bub-bles are worked out to the edge of the sheet with the viscose sponge. When completely in contact with the board, the paper is given an additional coating of paste on top.

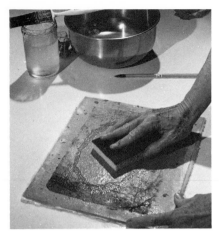 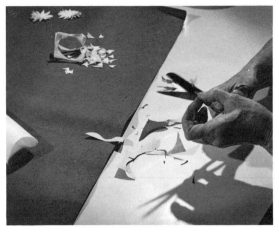

Fig. 23. Additional sheets of background paper, torn freehand with the wet-brush technique, are applied over the mulberry paper, which has been coated with paste. The new, dry paper is pressed down into the paste. The paste can be flowed beyond the edges of the overlaid pieces, as it does not show when the collage dries.

Fig. 24. While the background papers are drying, various elements of the collage are cut out and readied. All the flowers were prepared *découpage.* Papers were folded into stacks of several layers so that a single cutting produced a quantity of equal-sized flowers. Leaves were cut individually from heavy *kaji* paper, and were given a preliminary sizing-coat of paste on the rear side.

Fig. 25. The dried support now reveals three layers of background paper. At the bottom, the mulberry paper, then an overlay of *taiten* that has been prestained, and finally an opaque sheet of *moriki.* The latter gives a slight density to the center of the composition, where an illusion of a thickly filled bowl of flowers is sought. The vase has been cut from metallic-gold wrapping paper, and is ready to paste down.

Fig. 26. The vase has been pasted down on the support. A transparent overlay of thin *taiten,* prestained, is torn to fit parts of the vase, to give a sense of roundness, and these pieces are pasted down.

Fig. 27. Some of the leaves of *kaji* paper are pasted onto the support.

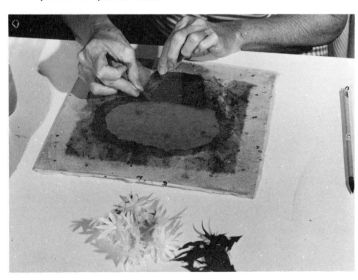 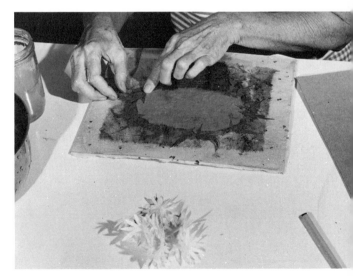

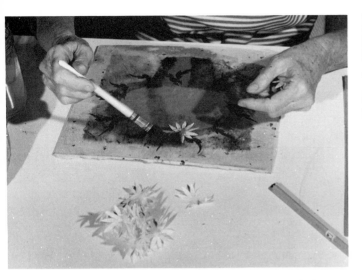

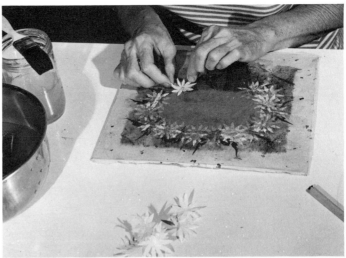

Fig. 28. Flowers are applied. The delicate Oriental tissue (*unryu*) used for the flowers requires that a light application of paste be used on the background; each flower is placed in position and is brushed down with additional paste. When wet, the flowers almost disappear, and this effect must not mislead one into applying more flowers than necessary to achieve the correct effect when the collage dries.

Fig. 30. The exciting transparency of the petals is emphasized by placing some of these forms directly on top of the opaque leaves, allowing the latter to show through. When the paper dries, some transparency will be retained, heightening the fact that these flowers are in front of the leaves.

Fig. 29. The flowers that are to appear toward the back of the vase are put down first; each successive placement moves toward the front planes. The flowers and leaves that are at the front part of the bouquet are put in last.

Fig. 31. Colored inks are used to give definition to the vase, create shadows, and give colored centers to the flowers. This work should be done only after the collage is dry, unless some bleeding of the colors is desired. As soon as the inks are dry, the collage is coated with a thin application of diluted polymer varnish. Two parts of varnish to one part of water is satisfactory.

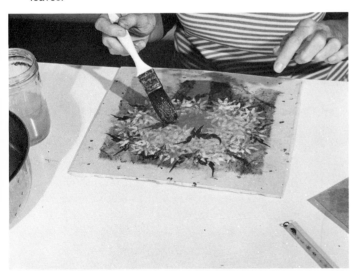

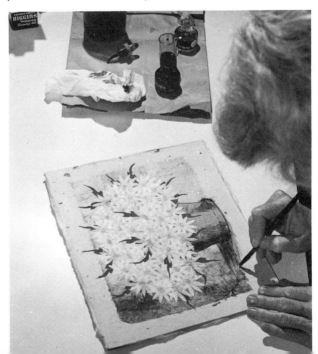

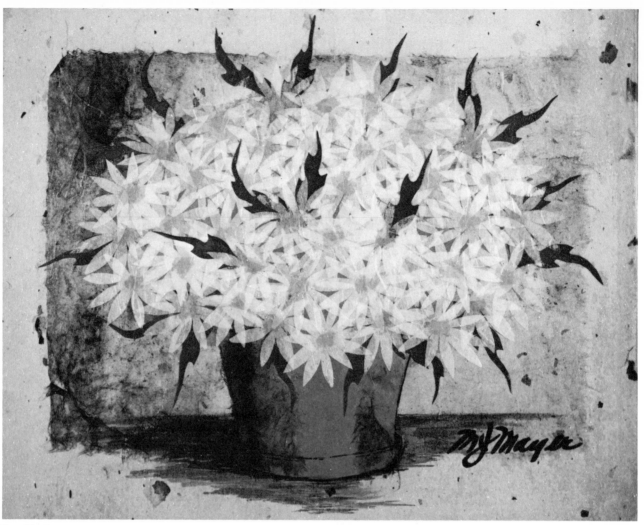

Fig. 32. Completed collage, *Daisies* by Mary Jane Mayer, is 10 by 13 inches.

It is also possible to work on a collage in progressive stages of pinning and pasting, altering the work as it proceeds and as the effects of the layered forms are studied. In the following series of photographs, we show how a particular collage, whose concept was well thought-out in advance and was based on prior experimentation, progressed through various stages. The background was laid down without pinning and changes were made until the desired feeling of perspective was achieved. The other elements in the composition were more problematical in their placement, so they were pinned in place tentatively and then studied and moved about. Additional changes were made after the main elements were pasted down.

Fig. 33. A piece of brown *moriki* was pasted down on a sized Masonite board. Over this a triangular piece of *chiri* is pasted.

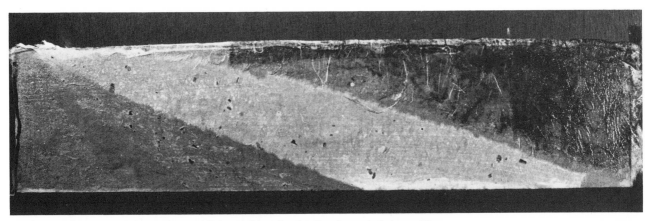

Fig. 34. On the upper right, a piece of lightweight stained *taiten* is pasted down. The staining of the *taiten* was done to give a feeling of depth, light, and shadow, calculated to create the illusion of a receding distance.

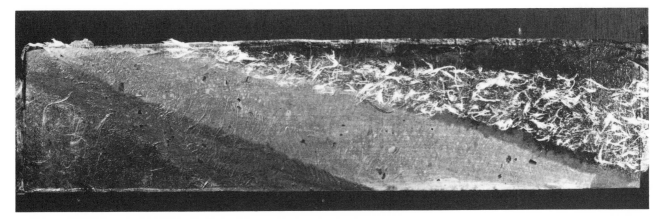

Fig. 35. Insufficiency in the dimensional illusion led to the application of a thin piece of *ungeishi* over the lower part of the *taiten.* The same paper was laid down in the lower left corner; this addition—while barely visible—increased the three-dimensional effect.

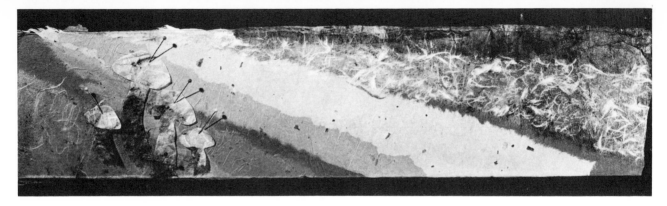

Fig. 36. Additional background layers are applied, still furthering the dimensional feeling. All background sheets have been torn. Mushrooms, which were cut from an irregularly stained sheet of *unryu,* are pinned in place tentatively. The cutting of the mushrooms took maximum advantage of the accidental effects in the staining, again to give roundness, depth, and form to the cutouts.

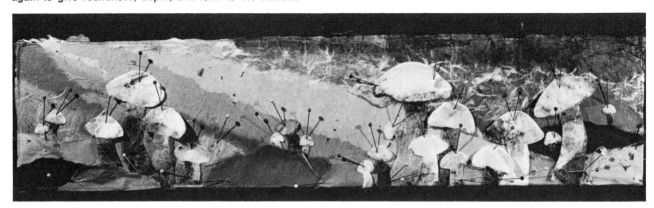

Fig. 37. Additional mushrooms are pinned down. At this point, it appeared that the caps of the mushrooms lacked "substance," did not appear "solid" enough. Improvement was accomplished by cutting out additional mushroom caps to lay over the original mushrooms, thereby reducing their transparency. Additional forms were added to the background to suggest shadows and to increase the illusion of depth.

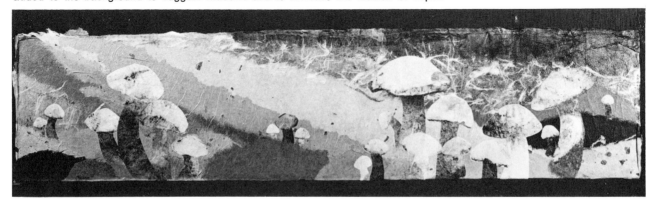

Fig. 38. The entire composition is pasted down.

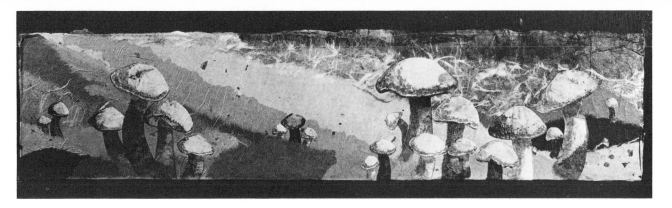

Fig. 39. The forms have been inked to emphasize structure and line. Brown, russet, and yellow inks and stains were applied with a watercolor brush.

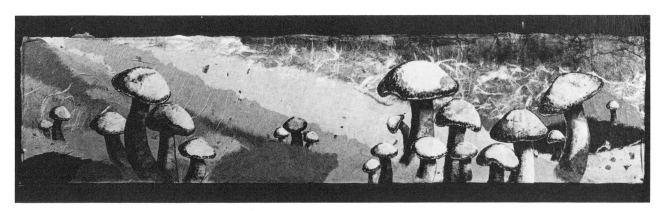

Fig. 40. Additional strengthening of forms was achieved with further inking. Normally, this would have been the final stage, except that study revealed certain weaknesses in the composition.

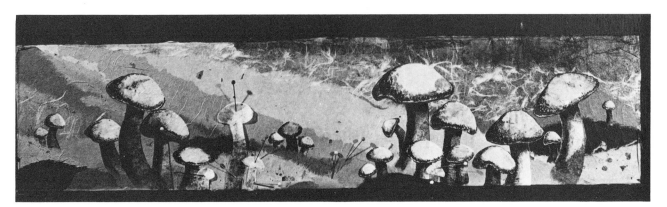

Fig. 41. Additional mushrooms were cut out and pinned in position. Shadows were added to the background in spots.

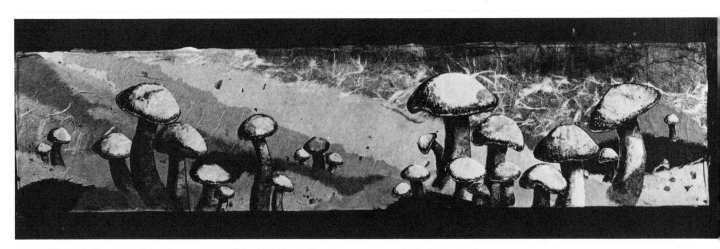

Fig. 42. To complete the collage, the added mushrooms were pasted down and inked for strengthening. The entire composition was glazed with diluted polymer varnish. The finished work, *Mushrooms #2,* is 6 by 27 inches.

4. Special Methods for Coloring Papers

The need frequently arises in collage making to have papers in colors that are not readily available from a dealer. Also, the random and special effects that are often desired can be achieved most successfully by coloring the papers yourself.

The process of coloring papers is a rather messy one, and we suggest that this work be done before making the collage, in an area (such as a garage) where spilled colors will not spell disaster, and where there is an abundance of room in which to work and to hang the papers up to dry.

The only piece of special equipment needed for the coloring is a large flat pan, such as a shallow baking tray or a photographer's tray. The pan should be big enough to accommodate the size of paper you wish to color, as the process involves floating the paper on water in the pan. For some special effects, however, papers can be folded prior to immersion in the dye bath.

Also, we recommend that a clothesline be strung up and the dyed papers be hung from this to dry.

Solid Colors

With the heavier and more durable papers, solid colors can be most easily achieved simply by immersing the paper in a tray full of dye bath, made of water-soluble dyestuff dissolved in water. Pigments are not suitable for the dye bath. Water-soluble aniline stains, used for staining wood, are reliable, easy to use, and quite permanent, and are the preferred dye choice. However, the color range of these dyes is limited. Batik dyes and the so-called "direct dyes" are second choices.

Fragile papers may be too weak to survive total immersion. In such cases, it is best to lay the paper on a clean sheet of newsprint and dab the color solution onto it with a sponge. Fragile papers should be allowed to dry before they are moved from the newsprint. Stronger papers may be hung from a clothesline after they are lifted from the dye bath.

Proceed with caution when mixing dyestuffs or dry aniline wood stains in water, as these products are very strong colorants, much stronger than pigments. The color you obtain will depend upon how strong you have mixed the solution and, when immersing the paper, upon how long the paper remains in contact with the solution. The most uniform results are obtained by using weaker solutions and allowing the paper to remain in contact for a longer period of time (or repeating contact when dabbing). Experimentation is the key to achieving the results you want. Both the papers and the dyestuffs are inexpensive, which justifies your making trials with small scraps of paper in a teacup of prepared dye bath. Adjustments to coloring procedures can be made on the basis of the dried samples.

For best results, mix only dyes of the same general chemical construction. You are less likely to run into difficulties if you confine your dye bath to a single family of products—avoiding such mixtures as a water-soluble aniline wood stain with a household fabric dye, for example. In compounding your dye bath, be sure to get rid of any lumps. Most powdered dyestuffs will dissolve better in a very small amount of water, making a kind of paste, which can then be dissolved in the large dye bath.

Special Effects

Swirling masses of color and random, irregular, or blotchy color can be achieved by a kind of modified "printing" process. The colors are realized on the surface of the water and the paper is carefully laid on the surface, where it picks up the color, and is then immediately removed.

Some effects can be achieved merely by sprinkling dry dyestuff on the surface of the water. Dyes react in many different ways, depending upon their characteristics. The behavior of any particular dye should be studied before any actual dyeing is attempted. Drop a tiny pinch of dry dyestuff on the water and observe what happens. Sometimes it will sink and disperse under the surface. Dyes which do this are not suitable for this "printing" process. Other dyes will disperse on the surface in fantastic shapes, sometimes reflecting currents of the water in the pan.

When two or more colors are placed on the surface together, they may interact with each other, sometimes creating fantastic, random effects. Merely placing a sheet of paper on the surface will capture the effect you see on the surface of the water. This process demands very rapid movement, however, to avoid excessive bleeding. The paper is simply lowered onto the surface and then, just as quickly as possible, lifted from it.

The best way to manage this is to grasp the paper by two diagonal corners, so that it hangs between the hands in a loop. Quickly lower the paper onto the surface of the water, the loop touching first, and then allow the corners to drop immediately. (See Fig. 47). Be sure to aim correctly so that the entire sheet falls onto the water. As quickly as possible, lift the sheet from the water and lay it on a flat surface, where it may be blotted with newspapers or paper towels to inhibit excessive bleeding.

Another "printing" method, one giving greater control of the dry dyestuffs, is to thicken the water bath. Several substances, such as cellulose paste

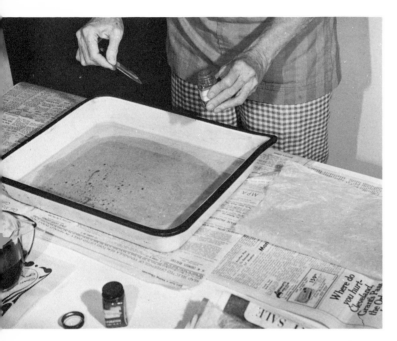

Fig. 43. Dry, water-soluble dyestuff is sprinkled on the surface of the water in a tray and quickly disperses, forming a random pattern on the surface.

44

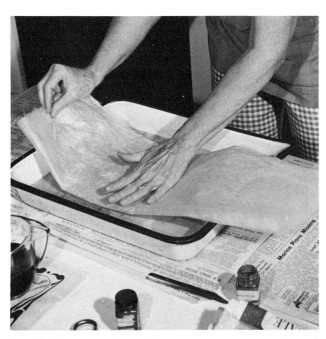

Fig. 44. Rice paper is quickly lowered onto the surface of the water. In this case, as only a small piece was to be cut from the paper after dyeing, only a portion of the entire sheet was placed in contact with the dye pattern.

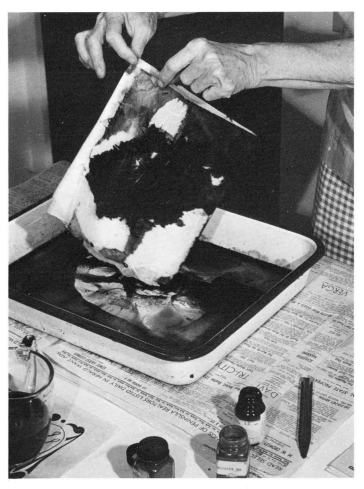

Fig. 45. The paper is carefully removed from the water's surface. The random pattern of the dispersed dyestuff has been transferred to the paper. If the paper is immediately laid on a flat surface and blotted, the design will be stabilized. If it is allowed to remain wet for any length of time, the color will tend to bleed, softening the edges and giving a more evenly blended appearance.

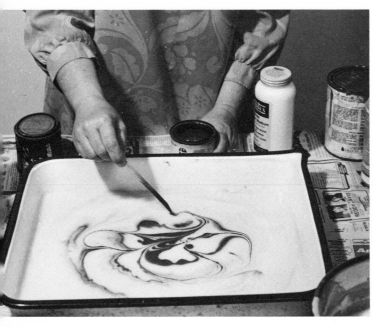

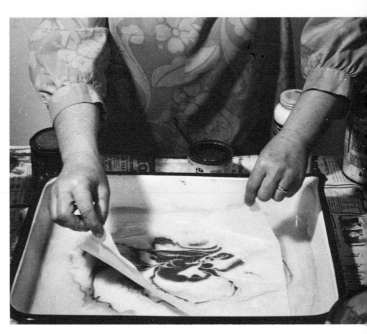

Fig. 46. Thinned, oil-based paint is placed on the surface of the thickened water and is directed into the desired design. In this case, the water was thickened by boiling it with cornstarch to obtain the viscosity of very heavy cream.

Fig. 47. The paper is held by two diagonal corners and quickly lowered onto the surface of the water.

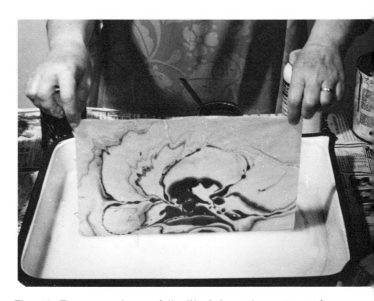

Fig. 48. The paper is carefully lifted from the water and then hung up to dry. (Marbleized patterns are not blotted.) Note how the design is completely "lifted" from the water's surface. This will not happen if the pigment layer is too thick, so it is important not only to thin the paint but to keep the pigment layer thin by not using too much paint and by spreading it out fully.

(the kind used in pasting down a collage), gum arabic, or cornstarch, can be used to make the water bath more viscous. This will inhibit the spreading of the dry dyestuff on the surface and permit some deliberate control of what happens. The amount of thickening agent to use will depend upon how much control you feel is necessary. Normally, only a very little thickening of the bath will be quite enough to give a degree of control consistent with the generally loose effect sought in a rice-paper collage.

Thickened water bases lend themselves especially to the use of "marbleizing" techniques, reminiscent of the end sheets often used in fine books of days gone by. To accomplish a modified marbleizing effect, use two or three different colorants—different in the sense that they are not soluble in the same medium (such as spirits-soluble and water-soluble aniline stain).

Dissolve each colorant in its appropriate solvent and flow each of these solutions onto the surface of the thickened water in the tray. As the media are mutually incompatible, they will "compete" with each other, each trying to occupy the maximum amount of surface. This chemical drama, fascinating to watch, can be manipulated with a comb or a stick dragged across the surface. When a suitable effect is achieved, the paper is laid down on the surface as previously described and the design is transferred to the paper.

Similar effects are obtained by using pigments dispersed in a small amount of binding medium and thinned with the appropriate solvent. The advantage of having dry pigments on hand is that the pigment can be mixed with almost any binder, such as linseed oil, gum arabic solutions, or polymer gel medium, which eliminates the need for stockpiling duplicate colors of oil-based and aqueous-based paints in tube form. However, such tubes of paint, or various oil-based printing inks, may be used provided the medium is sufficiently thinned with solvent (turpentine or mineral spirits for oil-based media and water for aqueous-based

media) to allow the solution to be flowed onto the thickened water bath. Although you can achieve some curious effects by allowing pigments dispersed in one vehicle to interact on the water's surface with dyes dissolved in another vehicle, you will generally avoid trouble and confusion if you stick to dyes or to pigments and do not use both together for these experiments.

Another very useful technique for a random effect is to sprinkle dry, spirit-soluble stain on a plain or thickened water surface, then add a few drops of paint thinner. A violent reaction takes place before your eyes, as the particles that were floating inertly on the water suddenly become animated to seek out the thinner and merge into it. Paper dropped during this display will capture absolutely marvelous effects.

Spots, Lines, Blobs

Dry pigments or dyestuff can be sprinkled on dampened paper for additional effects. Simply lay the paper down on a sheet of newsprint and sprinkle the pigments or dyestuff on it. Best results are usually obtained by picking up some of the dry powder on an old toothbrush and then scraping the brush across a piece of window screen from a height a few inches above the paper. This gives a fairly even dispersion of the particles. Depending upon the degree that the paper has been dampened, there will be a greater or lesser degree of bleeding of the colorant.

Another technique is to drop liquid dyes, or colored drawing inks, onto dampened paper, or to trace some lines with colored inks. These methods can also be used to enhance some of the effects achieved with the "printing" process.

Ingenuity and inventiveness pay off in many ways when you are dyeing papers. We discovered, for example, that a photographic tray with a bottom which was higher in the center than at the edges could give us an entirely new effect. After filling

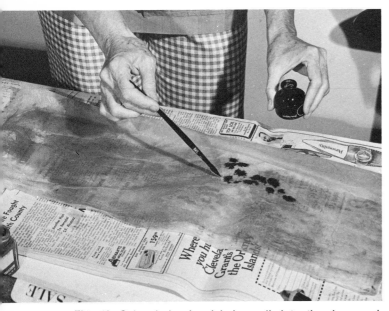

Fig. 49. Colored drawing ink is applied to the dampened surface of the paper with a brush.

the tray with water so that the high crown was just barely covered, we dropped some dry dyestuff into the water and noted that it dispersed quickly at the edges where the water was deeper, but at the crown, it remained controllable to a degree that allowed us to produce tight little configurations. The dyed paper, therefore, had configurations that were sharp at the center and grew progressively diffuse toward the edges.

Dye solutions painted on a sheet of glass, and then transferred to the paper by printing the glass, offer a high degree of control which might be useful in some collages. In general, however, we find that more random effects are better.

The coloring of papers offers such an immense opportunity for getting variety and individual effects in a collage that we urge you to incorporate some dyed paper in every rice-paper collage made according to our basic method.

You should accumulate a collection of papers that you have colored and, when you begin a new collage, have this material in front of you, both for the inspiration it may offer and for the need that will almost certainly arise for some of it as you proceed with your design.

5. A Few Words About "Inspiration"

Technical "know-how" is not all there is to the making of a work of art. Indeed, it is probably the least important aspect of what we think of as art.

The important element, inspiration, is elusive and cannot be learned in any step-by-step approach. However, it is something that can come

Fig. 50. *Waterlily,* Mary Jane Mayer. Rice-paper collage, 10 by 12 inches.

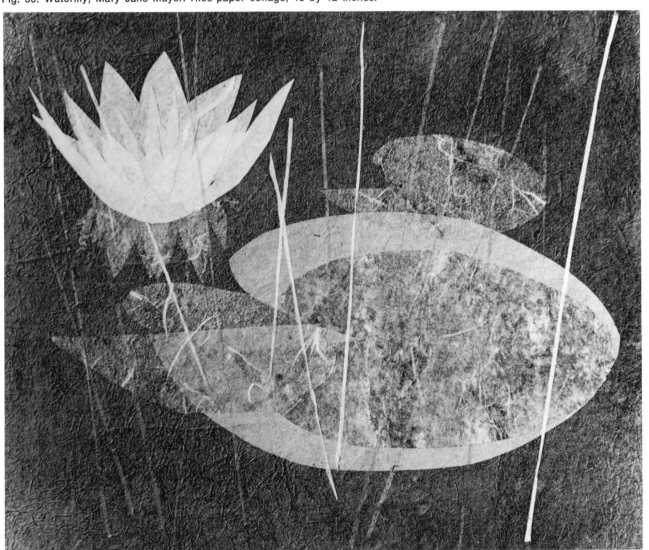

from training. Getting your own deeply rooted attitudes and feelings to show in something you do with your hands is in part a result of *talent,* but in a larger part it is probably much more the result of a prosaic quality: a willingness to work and experiment. In getting others to strike out on their own and make collages that reflect their own insights, we have developed a few approaches which we would like to suggest at this point.

Henry Miller, in his delightful book *To Paint Is to Love Again,* has given us a manual on the subject of talent and inspiration. We would urge that any beginner in any art or craft read this book.*

Miller's thesis is simply that you get involved, that you do *something,* and that the process of the doing is what creation is all about, the final product being somewhat incidental, though not unimportant. If you are too concerned with the final result before you begin, you are already encumbered by difficulties; you are building into your work discouragement and disappointment. But if you merely begin, and then let what happens lead you further into it, allowing the results to take care of themselves, you discover that you are indeed inspired and all kinds of things begin to happen that you couldn't possibly have foreseen.

As an example, according to Miller, if he started out to paint a barn door and it happened to look more like a beached whale, he would change the whole concept and go ahead and paint a whale. "If the mood is right and the urge strong enough," he says in his book, "the picture will come out all right even though the houses lie on their sides, people walk with lion pads, rivers run uphill, saints look like madmen and women like cows."

Collage lends itself beautifully to this kind of involvement. As Miller might have laid down a light watercolor wash and then studied it to see what it might suggest, so in collage a simple sheet of torn

natsume laid down on a support can begin to suggest things. It is this kind of planned "fooling around" that often yields the richest dividends.

The main thing is to start. Don't be unduly intimidated by a blank surface which seems so full of potential and yet so terribly remote or beyond your capability. No artist has ever confronted his blank canvas without some deep feeling of terror, but all learn eventually that, once "into it," once something is started, the rest moves along rather well.

So when you have sized a board and you have a pile of virgin rice paper and a nice pot of paste in front of you, start by cutting and tearing the papers. As you do this, more or less randomly perhaps, you will feel something about the paper. There is no telling *what* you will feel, but it will offer something else to your imagination, and before long you are into the work. You may have to call the results an "abstraction" when you are all done, but we're ready to guarantee that this experience will already have suggested the next project to you.

In any case, don't work too small. Collage should be done large, somewhat flamboyantly, even carelessly. Allow the fantastic textures of the papers to show themselves in the work. Pile papers on top of each other to see the effects of one texture as seen through another. The subtleties will enchant you and stimulate further adventures. Contrast cut and torn edges. Explore various color schemes and color blending. Go back to the dyeing operation if you think you can improve on some color or want to get some new effect.

If this way of getting "into it" seems too "unstructured," you can "copy" another collage, such as one of our flower studies. The one thing you will quickly discover, if you do this, is that copying will almost certainly not result in a very close rendition. Inevitably your own "handwriting" will prevail; the finished work will be more your own than you expected it to be. It would be rather out-of-the-ordinary if, in the process of copying something, your own imagination did not assert itself somewhere along the line. You do begin to incorporate

*Miller, Henry, *To Paint Is to Love Again*. Grossman Publishers, New York; 1968.

Fig. 51. *Hibiscus,* Mary Jane Mayer. Rice-paper collage, 24 by 32 inches.

differences into the work, in effect, personalizing it.

The materials of collage in themselves can be a lively source of inspiration. Gather up a goodly supply of rice papers and other papers, textiles, foils, etc., and see what these suggest. Very often, discovery of a new kind of paper is enough to suggest a whole new collage.

Sometimes a *use* for a collage, an area of empty wall, perhaps, will awaken a desire to start something. You may not be able to think of a design immediately, but if you get started even dyeing some paper the right color, before you get very far along, the exactly right idea for the design will fairly burst upon you. So trust those impulses and move forward!

After you have made a few collages, another powerful stimulus will come into play: criticism. As you study what you have done, you will see how the work could have been improved. You may discover awkward tensions, such as a serene flower study with some areas where the contrast of hard-edged *découpage* forms clash with the feathery effects of *déchirage* forms, instead of complementing each other. You can then return to the paste pot, but now with surer direction!

The process of inspiration is so simple that one deplores the cult of mystery which has grown up around it; it is merely doing and allowing the doing itself to direct more doing. We, therefore, encourage you to proceed.

6. Mass Production of a Decorative Collage

Rice-paper collages lend themselves readily to mass production methods and many examples have found their way into the interior decoration market, where they are used in the décor of hotel rooms and public buildings.

A typical commission and the means by which it was handled are described on the following pages. The method used was essentially the same as described in our basic method; however, several shortcuts are possible when quantity is involved. In addition, the work had to be carefully organized and supervised in terms of procurement of materials and management of assistants.

Project Definition

The interior designer of a large hotel negotiated with the artist in matters of price, design, delivery, and so forth, for 1,326 collages to be used as the main wall decoration in as many hotel rooms.

The requirements were agreed upon, and these included a stipulation that, although the basic design would be the same, each collage would be "different," this difference to be achieved through random effects in the background. Two color schemes would be employed, to co-ordinate with the color schemes of the rooms (see Color Plates 12 and 13).

Design Considerations

A well-organized project of such large scale requires that only readily available materials be used, that no laborious or time-consuming methods (déchirage, for example) be employed, that

Fig. 52. Template for mass producing a collage.

the design be simple enough to be readily understood and executed by relatively untrained assistants, and that the entire design lend itself to the use of templates for layout and an orderly system of assembly and pasting down. The random effects creating the "differences" had to be non-critical ones, so that practically any results achieved would be usable and not interfere with the effectiveness of the composition.

With these considerations in mind, a trial collage was made and the design was verified with the interior designer in charge of installation. Upon acceptance, the design was translated into a template which identified each component by number, indicated where each piece was to be placed, and showed the order in which they were to be pasted down (Fig. 52). A separate, carefully outlined drawing of each element on the template was then made as a guide from which a metal die would be cast by a professional. The dies were to be used to cut the necessary quantities of each component.

Calculating the total number of the various papers that were needed, the amount of paste and tools necessary for execution, the work space, and so on, were all part of the design process. However, as much of the work as possible was subcontracted so that primarily precut papers were delivered to the workshop.

The Making

The specifications called for each panel to be 24 by 32 inches, and 1⅛ inches thick, with a top surface of smooth Masonite hardboard. The panels, therefore, were made of 1-inch particle board and a ⅛-inch sheet of Masonite, cut to size and laminated at the lumberyard.

Each panel was sized with a thin coat of wheat paste. Wheat paste was the chosen adhesive throughout. In the large quantities needed (200 pounds), wheat paste offered the advantages of price and convenience. Spoilage was not a prob-

lem due to the rapid use of quantities mixed up.

The first background paper was a heavy, plain, colored wallpaper; these sheets were cut to size in the studio, by assistants. Two colors were used, one for each color scheme, and each piece was cut larger than the support so the edges could be folded over to the rear of the board. Paste was evenly applied to the back of the wallpaper with a conventional wallpapering brush. A coat of paste was also applied to the sized board and paste was carried around the edges to the back. The wallpaper was then centered on the panel and pushed down with another brush, working from the center outward so as to remove any bubbles or irregularities. The extra margins of the background paper were folded to cover the raw edges of the board and were extended around to the underside of the board. The corners were carefully trimmed and made into a box fold. As a result of covering the panel in this way, no further edge finishing would be required.

The second background sheet, smaller than the first, was white tissue paper, again cut to exact size (by the supplier) and dyed a neutral brown color. These sheets were stained prior to pasting by lightly sprinkling ½ teaspoon of oil-soluble aniline stain on the surface of water held in a large flat pan, then pouring on a small amount of paint thinner, which dissolved the dye in large, irregular blobs. The paper was dragged across this surface quickly, then hung on a clothesline to dry. This method was repeated for each sheet and resulted in a great variety of different, random distributions of color. As these sheets were to show prominently in the finished collage, the requirement of "difference" was met with this step alone.

Additional paste was applied to the surface of the wallpaper, and the sheet of stained tissue was centered on the background and pasted down, using a damp viscose sponge to work out the bubbles.

The foregoing operations were easily worked out in a modified assembly line technique. When the supports had dried overnight, the rest of the floral design was sketched on each surface lightly in pencil by assistants using a template as a guide.

The Template

Each template was made of heavy-gauge sheet acetate, frosted on one side. It was cut to the exact size of the support, so that alignment was simplified. The design of the collage was traced on the frosted surface of the template and the outlines were cut out within the shapes, making them smaller than the die-cut paper pieces would be (see Fig. 52). The reason for this was to eliminate any possibility of pencil marks showing outside the paper forms after they had been pasted down. Marks safely inside the forms would be securely hidden. Each blossom, leaf, and calyx was identified by number on the template, and the order in which each was to be pasted down was also indicated. A template was provided for each worker, who sketched the design onto each of the panels assigned to him and did the entire assembly of those collages from that point on.

The Parts of the Collage

The blossoms, leaves and calyxes, the vase and its shadow, were all die-cut from various sheets of paper. The dies were made by a tool and die maker according to our line drawings; and a button factory, using a large hydraulic press, did the actual cutting. With this method, a huge number of pieces were cut at a single time.

About 1500 sheets of various papers were used for the several elements in the collage. In the yellow-flowered version, the flowers were of stock-dyed *natsume*; the pink flowers were of plain "flower paper," a euphemism for toilet tissue. Both papers were cut with the same dies. Leaves were made from a plain, stock-dyed, heavy-weight *moriki*.

The vase was gold-metallic wrapping paper; its shadow was plain white tissue, stained in the same manner as the second background sheet. (This random coloration contributed further to the subtle "difference" requirement.)

All the die-cut pieces were put into sets of boxes, with each box numbered—to match the assigned numbers on the template—according to the element it contained, and a set of boxes was distributed to each worker.

Order of Assembly

The vase was placed in position first. To create an antique effect, the gold wrapping paper was crumpled and then smoothed out before pasting. Next, the shadow was pasted onto the vase. Then, following the sketched marks of the template, the flowers and leaves were pasted down as described in the basic method, beginning at the top and working down. Paste was applied to the support only and the elements were brushed down with a paste-filled brush. The order in which each item was put in place followed the numbers on the template.

When all the pieces were pasted down, the entire surface was gently wiped with a viscose sponge to remove any excess paste, and the collage was put aside to dry.

Finishing

A black felt-tip pen was used to draw an outline around the vase. The signature was done with a rubber stamp.

The entire collage was sprayed with Scotch-Gard, which is quicker than a glazing coat, and which gives sufficient water-and-soil resistance to meet our specifications.

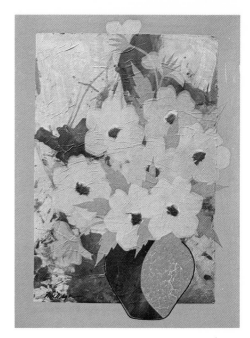

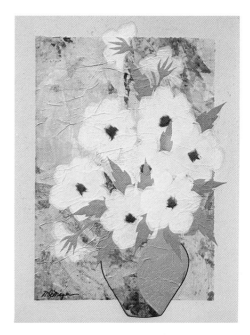

Color Plate 11. *Fleurs,* Mary Jane Mayer. Rice-paper collage, 24 by 32 inches.

Color Plates 12 and 13. *Hawaiian Bouquet,* Mary Jane Mayer. Rice-paper collages, 24 by 32 inches. Two versions of the same design were mass produced with the aid of a template and die-cut papers.

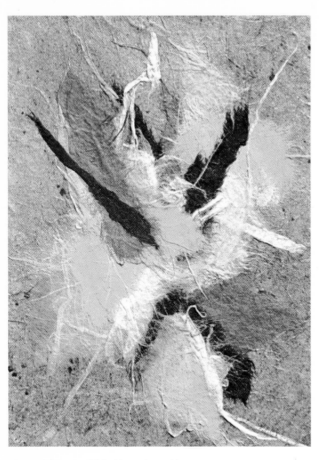

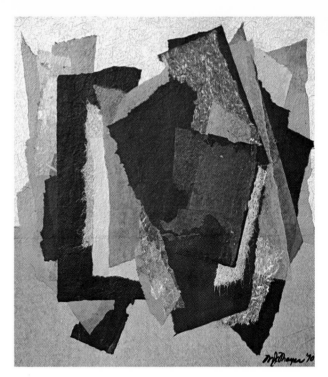

Color Plate 9. *Pali,* Mary Jane Mayer. Rice-paper collage, 36 by 38 inches.

Color Plate 8. *Oh?,* Mary Jane Mayer. Rice-paper collage, 11 by 14 inches.

Color Plate 10. *Phoenix,* Mary Jane Mayer. Rice-paper collage, 40 by 55 inches.

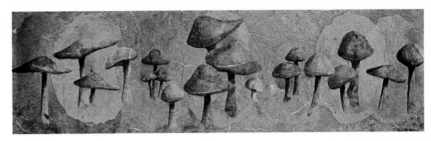

Color Plate 6. *Mushrooms #1,* Mary Jane Mayer.
Rice-paper collage, 6 by 18 inches.

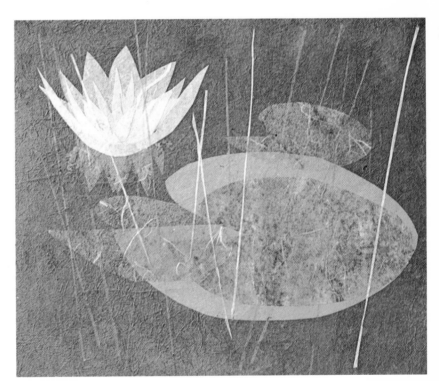

Color Plate 7. *Waterlily,* Mary Jane Mayer. Rice-paper collage, 10 by 12 inches.

Color Plate 5. *Cattails,* Mary Jane Mayer. Rice-paper collage, 14 by 40 inches.
Note the placement of the wide yellow strip to establish an important line of
perspective, as well as the shadow treatment on the vase. These devices show
a simple means to achieve depth in a collage composition.

Color Plate 14. *Upland Forest, Kipahulu,* John Kjargaard. Collage and acrylic, 32 by 44 inches.

Color Plate 15. *Hawaiian Armour*, John Kjargaard.
Rice-paper collage and acrylic paint, 36 by 36 inches.

Color Plate 16. *Sounds of the Sea,* Helene Cailliet.
Opaque and transparent papers, 16 by 20 inches.

Color Plate 17. *The Broken Box,* Helene Cailliet.
Opaque and transparent papers, 14 by 18 inches.

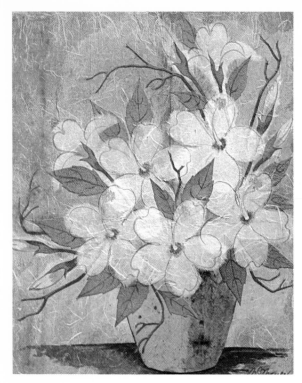

Color Plate 3. *Hibiscus #2,* Mary Jane Mayer.
Rice-paper collage, 20 by 24 inches.

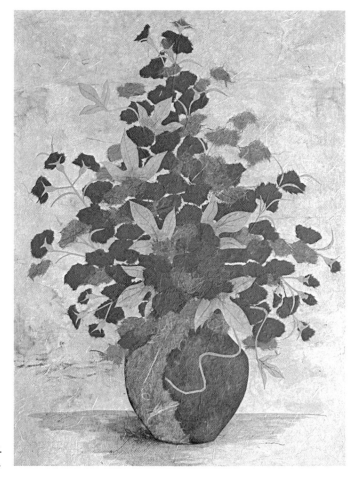

Color Plate 4. *Cornflowers,* Mary Jane Mayer.
Rice-paper collage, 24 by 32 inches.

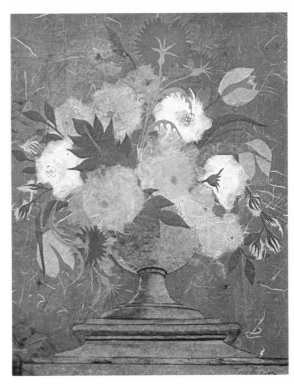

Color Plate 1. *Baroque Bouquet,* Mary Jane Mayer.
Rice-paper collage, 20 by 25 inches.

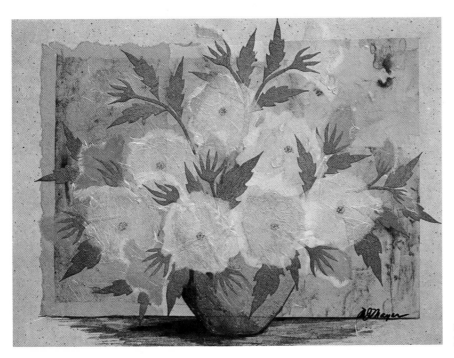

Color Plate 2. *Parfait,* Mary Jane Mayer.
Rice-paper collage, 24 by 32 inches.

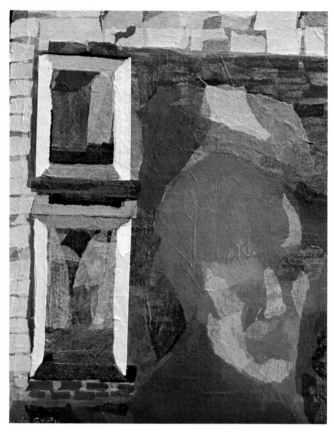

Color Plate 18. *Windows and Red Man,* Helene Cailliet.
Opaque and transparent papers, 14 by 16 inches.

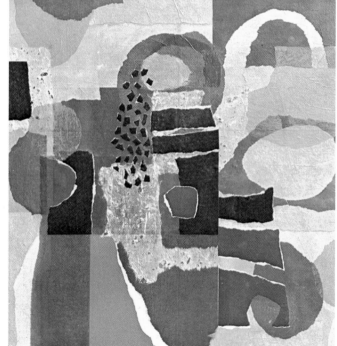

Color Plate 19. *Within a Square,* Helene Cailliet.
Opaque and transparent papers, 14 by 14 inches.

7. Acrylic Washes on Rice Paper

Like many artists working in collage, John I. Kjar-gaard finds the versatile qualities of Japanese rice paper perfectly suited to his subject. Living in Hawaii, he is surrounded by the brilliant colors of flowers, the sea, and rock, and he feels that the textures and colors of these papers reflect the Hawaiian landscape to perfection.

However, Kjargaard is concerned that his collages be every bit as permanent as paintings, not a small challenge in a medium which is somewhat

Fig. 53. *Summer in Manoa,* John I. Kjargaard. Rice-paper and acrylic collage, 32 by 32 inches.

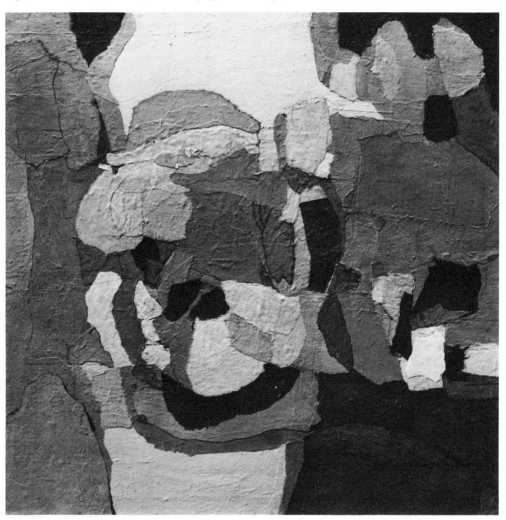

Fig. 54. *Landscape Kilauea,* John I. Kjargaard. Rice-paper and acrylic collage, 44 by 44 inches.

fragile by nature! Since the colors of some of these papers are not as permanent as Kjargaard would like for them to be, he has discovered a means of protecting them by using thin washes of acrylic paint. Placing washes over these papers offers the double advantage of giving a protective screen and, at the same time, of permitting a modification of the color.

As supports, Kjargaard favors canvas for his larger works, Masonite for small pieces. The cut and torn papers are laid out on the support and pinned in position while several trial compositions are studied. Sometimes this part of the work occu-

pies two or three weeks. When a satisfactory composition is achieved, the papers are pasted down with wheat paste, to which a small amount of polymer medium is added. Some compositional changes are made and the tints of diluted acrylic paints are added to the papers right through the gluing process.

The completed collage will often get a few additional washes of acrylic paint, or—for accents—some heavier layers of paint; then, when it is dry, it will be coated with a mixture of two parts of polymer matte medium (Liquitex brand) to one part of water.

Fig. 55. *Halemaumau*, John I. Kjargaard. Rice-paper and acrylic collage, 37 by 40 inches.

59

Fig. 56. *Symphonie O,* Helene Cailliet. Various papers with acrylic paint, 18 by 18 inches.

Fig. 57. (Opposite page) *Lost Keyhole,* Helene Cailliet. Paper collage with acrylic paint, 16 by 16 inches.

8. Printed and Dyed Papers

Another artist in Hawaii, Helene Cailliet also turns to the lush, color-rich landscapes around her as an endless source of inspiration. Her work also reflects Hawaiian history and a deep appreciation of many of the Polynesian arts and crafts, as seen in her use of tapa-cloth motifs.

This artist achieves her extraordinarily brilliant collages through the use of many kinds of printed and dyed papers, most of which have been printed or colored in the manufacturing process. Paper napkins, gift-wrapping paper, wallpaper, rice papers, and papers with embossed textures, are

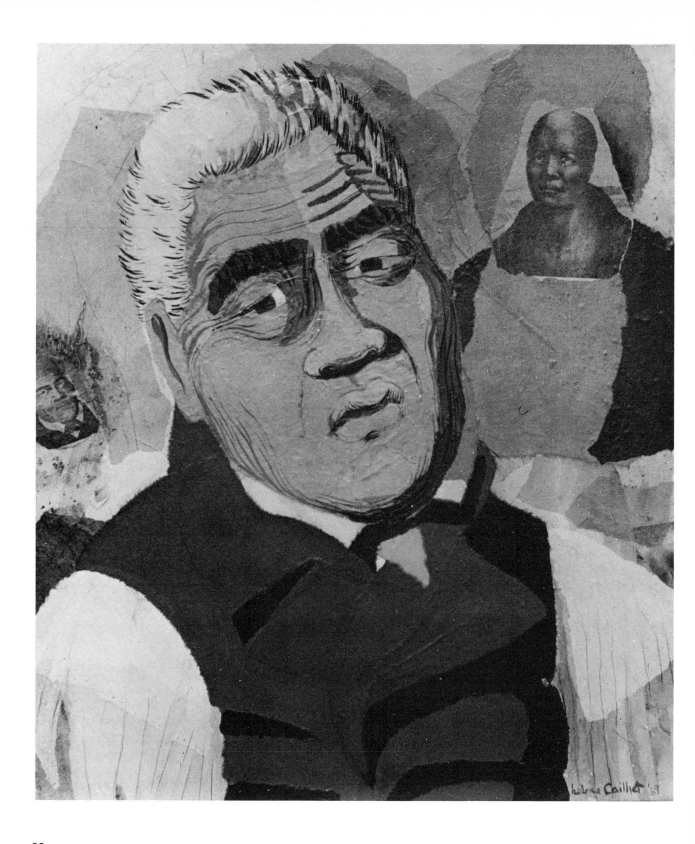

（signature）helene Caillet '69

among her preferences. Occasionally, the very heavy textures of chair caning or upholstery fabrics are used. Mrs. Cailliet sometimes colors her papers before applying them to the collage; at other times she works in additional colors, using acrylic paints, after the papers have been applied. An adept use of contrasting and complementary colors lends great vitality to her compositions.

The procedures of the Cailliet workshop in Honolulu are not very different from those specified in our basic method, except that polyvinyl-acetate emulsion, diluted, is the preferred adhesive for the papers. Mrs. Cailliet reports that, while this material is more difficult to use in pasting, its greater adhesive properties, its durability, and its imperviousness to moisture make it worth the effort to conquer some of the difficulties of its use.

The finished collage is glazed with a layer of matte polymer varnish, which is also applied to the edges and back of the collage support.

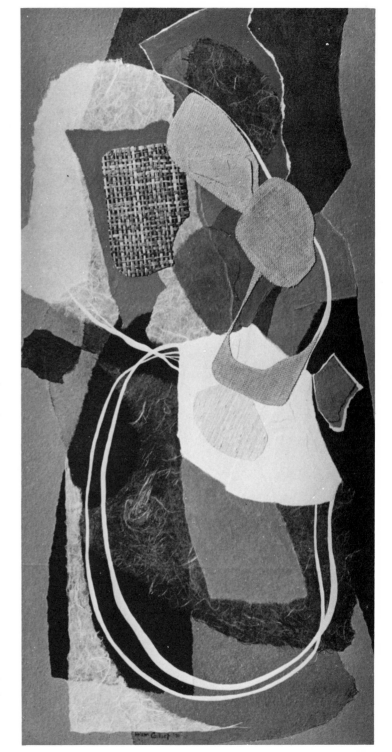

Fig. 58. (Opposite page) *Interpretation of Ta-me-a-me-a,* Helene Cailliet. Collage and paint portrait, 20 by 20 inches.

Fig. 59. *Greenscape,* Helene Cailliet. Textiles and papers, 16 by 32 inches.

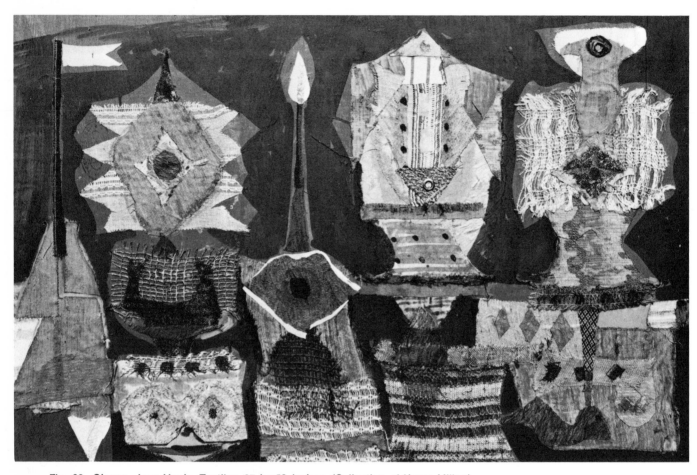

Fig. 60. *Choros,* Jean Varda. Textiles, 37 by 50 inches. (Collection of Henry Miller.)

9. Textiles

The collages the late Jean Varda turned out in an almost steady stream were described by him as "mosaics made with light materials." He gathered scraps of brightly colored brocades, damasks, twills, and suitings from upholstery shops, interior decorators' studios, and other sources. The cheerful, bright colors pleased him most and he would turn the swatches into his favorite subjects: the birds, unicorns, nymphs, and half-human, half-animal creatures of bestiary and of Greek mythology.

Each Varda collage told a story, but each was also a reflection in microcosm of his ebullient life. To him, life was simply one grand occasion to celebrate. He lived in a huge houseboat-studio, half-buried in the mud at Sausalito, California, where he surrounded himself with a veritable museum of flotsam and jetsam—in itself the most gigantic collage ever made!

Varda was not scrupulous about his techniques and, as a result, a reverent owner of one of his collages may occasionally have to glue the whole thing back together. But despite their fragility—which, it might be argued, is part of their very character—the whimsical, rag collages of Jean Varda do illustrate how enthusiasm and inventiveness can make wondrous things from the castoffs too many of us would relegate to the scrap heap.

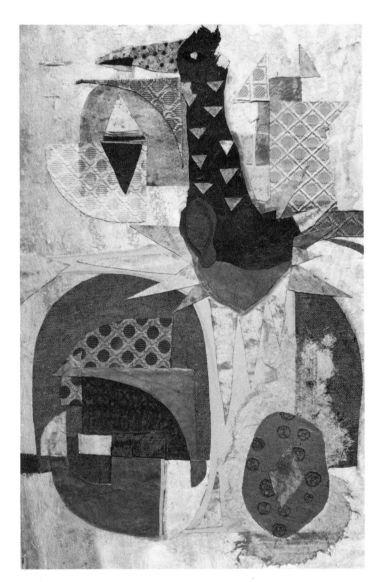

Fig. 61. *Phoenix,* Jean Varda. Textiles, 40 by 60 inches. (Collection of Henry Miller.)

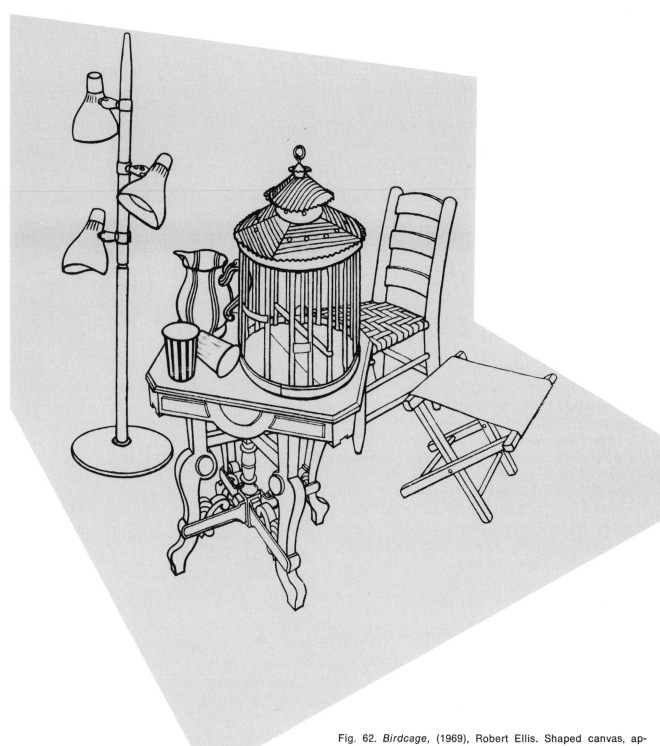

Fig. 62. *Birdcage,* (1969), Robert Ellis. Shaped canvas, approximately 60 by 60 inches.

10. Figurative Cutouts on Canvas

The relationship between collage and other visual methods of expression is open to vast areas of experimentation. As one example, the opportunity which collage affords to study a composition and make alterations in advance of any final decisions led Albuquerque painter Robert Ellis into new aspects of both drawing and collage.

Ellis was working with very simplified line drawings of figures and objects in genre settings, working almost life-size on shaped canvases. The drawing was deliberately reduced to its barest forms, amplifying the mundane, pop quality of his subject matter. Into such life-size drawings, Ellis began to introduce actual, ready-made objects, in much the same way that Picasso introduced a piece of chair caning into his first, and now historical, collage. Ellis included playing cards and covers of *Time* magazine.

Soon he discovered that by making each of the elements of his drawing on separate pieces of canvas, cutting them out around their outlines, and then arranging them on the canvas, curious juxtapositions and optical effects could be achieved that would never have occurred had he attempted to draw the objects in place from the beginning. Thus, a chair drawn in one perspective and introduced into a composition that was seen from another perspective created an intriguing visual tension. A canvas shaped to suggest the corner of a room and then populated with figures and objects, often drawn from a perspective slightly different from that of the suggested room, became an amazing display of optical illusion.

Ellis has now perfected a new collage approach that begins with carefully executed and very realistic outline drawings on canvas. These are then cut out, somewhat like paper dolls, and arranged on

Fig. 63. Cutting out the figures

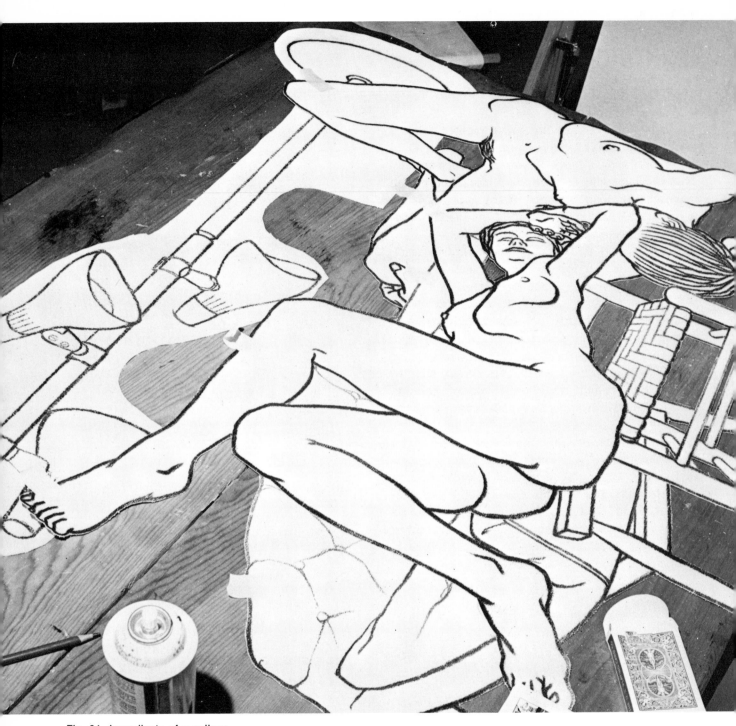

Fig. 64. Ingredients of a collage.

canvas, with the elements temporarily held in place by small pieces of masking tape. He makes very little attempt to previsualize any final composition, but simply accumulates, as interest may direct, a collection of figures, lamps, furniture, birdcages, and other objects. These are drawn from a variety of perspectives. From this collection of miscellaneous drawings Ellis begins his collage.

So provocative has the method been that Ellis finds several "workable" compositions can result from one set of ingredients, and he often finds it necessary to make duplicate drawings in order to realize the many possibilities.

When the various elements of the collage have been brought together in a satisfactory composition, Ellis proceeds to paste the entire work together. A heavy coat of undiluted polyvinyl-acetate emulsion is applied to the back of the piece to be pasted down, which is then carried to the background canvas and placed in position. It is pressed down as required and any bubbles formed beneath the piece are worked out to the edges with the fingers. Care is used to avoid smudging the charcoal outline drawing. Alternatively, fixative can be applied to the canvas figures before mounting.

The final composition, completely pasted down, is allowed to dry and is then given several coats of charcoal fixative. Occasionally Ellis introduces a small note of color in some canvas elements of the composition, using acrylic paints.

Fig. 65. Assembling the collage.

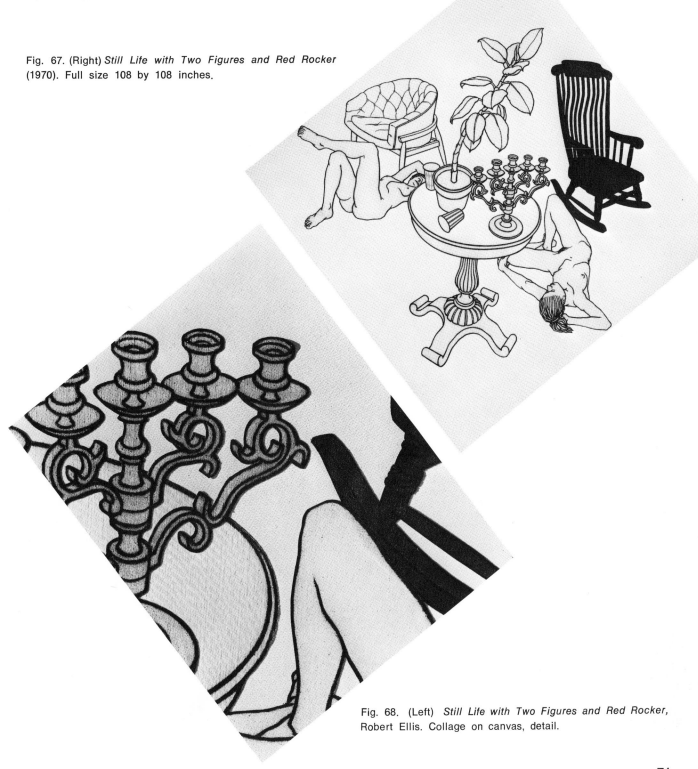

Fig. 66. (Opposite page) Experimenting for placement.

Fig. 67. (Right) *Still Life with Two Figures and Red Rocker* (1970). Full size 108 by 108 inches.

Fig. 68. (Left) *Still Life with Two Figures and Red Rocker*, Robert Ellis. Collage on canvas, detail.

72

11. Collage as a Textured Ground for Acrylic Painting

Many painters have discovered that an underlayer of collage, utilizing varied textures of papers, fabrics, and foils, etc., can greatly enhance the depth and the interest of the painted layers applied over them. Ora King, an art instructor from Denver, utilizes this technique in her brilliantly colored acrylic landscapes and still lifes.

In *Cienega* (Fig. 69 and Color Plate 24), the underlying collage has determined the final effect far more than the surface painting has. Choosing the heavier texture of *natsume* for the foreground, and the lighter-textured *taiten* for the background, Mrs. King has established in a subtle way what we all observe in nature: the more explicit depth and texture of foreground objects in contrast to the more diffused and softer textures of objects at a greater distance.

The step-by-step procedure for *Cienega* began with the preparation of the support; in this case, canvas was primed with Liquitex brand polymer gesso. The selection and tearing of the papers came next. For the foreground, a large piece of *natsume* was torn into smaller pieces, taking particular advantage of the "lay" of the conspicuous paper fibers, with a view to arranging these in the paste-down to suggest stems and branches. Additional papers to be used in the middle ground and background were torn; these included *ogura, unryu,* and *kinwashi,* as well as the *taiten.* The canvas was coated with polymer medium, and each piece of paper was carefully saturated as it was immediately brushed down on the canvas. After the collage had dried, both dry-brush and glazing techniques were used with acrylic colors to complete the painting.

In *Cienega,* the collage is subordinate to the painting, and is simply a textured "underpainting." Another illustration of this approach, more abstract in concept, is *Still Life, Vase* (Color Plate 25), in which burlap was used in the underpainting.

Fig. 69. *Cienega,* Ora King. Acrylic painting over rice paper.

Stone Wall (Fig. 70) utilizes rice paper that is cut and torn to suggest the shapes of rocks and the pieces are used to literally construct a wall, much as a mason might do it. In *Memories of a Garden* (Color Plate 22), the textured rice papers endow the subject, painted rather abstractly, with a kind of reality which the smoother surface of an ordinary canvas would not have produced.

Bent Chair (Color Plate 23) permits the collage element to dominate the painting. Here a variety of papers was used, including some unusual, French, handmade wrapping papers. Tissue papers (specially colored beforehand, with polymer paints, by the artist) were laid down in multiple layers and then lightly glazed, giving the painting an extraordinary transparency.

Fig. 70. *Stone Wall,* Ora King. Rice-paper collage, 14 by 20 inches. The rock shapes were cut from papers that had been colored beforehand with very dilute acrylic paints to suggest the natural colors and textures of rocks. These pieces were then assembled into a wall by fitting each "rock" into place very much as if one were building an actual wall. Following the completion of the assembly, thin acrylic washes were added to create an overall atmospheric effect. One advantage of using acrylic paints for coloring papers is that, once they have dried, there is no danger of their bleeding when additional washes are applied.

12. Bas-Relief

While the use of collage as a textured underpainting achieves a surface similar to impasto, allowing the heavily textured forms themselves to dominate the canvas creates a more sculptural effect. Eerie figures floating from the mysterious canvases of Denver painter and collagist Ruth Todd represent an original and highly imaginative use of the collage technique in this vein.

Deeply crushed linen duck, or sometimes coarse burlap, is frozen into almost painfully distorted shapes, reminding one of the shrouds of an ancient mummy. There is something very other-worldly and ethereal, at times macabre and at other times strangely compelling, in these large collages.

Mrs. Todd's technique illustrates a very simple means used to achieve powerful emotional effects. Beginning with a plan, a poetic concept, perhaps, she carefully plans her collage in advance. The

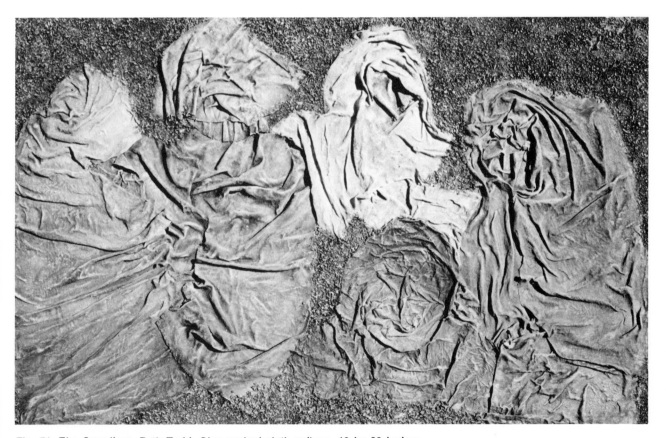

Fig. 71. *The Guardians,* Ruth Todd. Glue-soaked cloth collage, 18 by 32 inches.

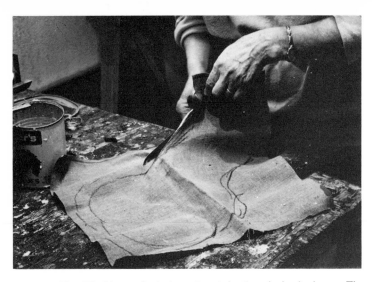

Fig. 72. Linen duck is cut out in the desired shape. The outline is drawn somewhat larger than the figure is to be when completed to allow for shrinkage when the fabric is wrinkled and molded.

figures are cut out roughly and somewhat larger in size than will be finally realized; the fabric pieces are soaked in PVA glue solution and squeezed to create wrinkles. The glue-soaked figures are then laid out on the prepared support and twisted, compressed, often tortured into the required shape (Figs. 72 to 75). Once a satisfactory composition has been achieved, the crushed fabric is allowed to dry and further effects are created in painting the collage (Figs. 76 and 77).

Often Mrs. Todd discovers in the early stages of the collage that the saturated, crushed fabric itself will force her away from her original concept into something entirely different; and some of the strength of her work perhaps comes from the tension between the attempt to work out an original concept and the force of the medium itself moving in another direction. Thus, she once started a com-

Fig. 73. The duck is gathered into a lump and put into a mixture of PVA glue and water (two parts glue to one part water). The fabric is allowed to soak up glue until saturated and, during this process, it is occasionally lifted out and wrung out by hand. The more wrinkles that can be created this way the better, as this softens the fabric and makes it more pliable in later stages. While the fabric is soaking in the glue, the support may be prepared.

Fig. 74. A Masonite panel or other support is sized with a mixture of PVA glue (two parts) and water (one part). A second sizing coat is applied after the first has dried. Depending upon the final conception of the collage, sawdust and shavings of different textures are sprinkled on the wet, glue surface. Additional layers of sawdust can be built up once the first layer has dried sufficiently so that it will not brush off when another layer of glue mixture is applied.

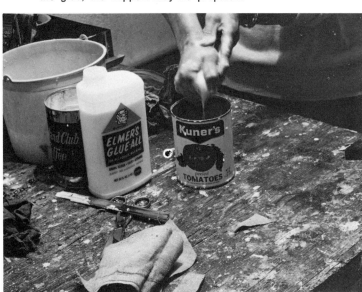

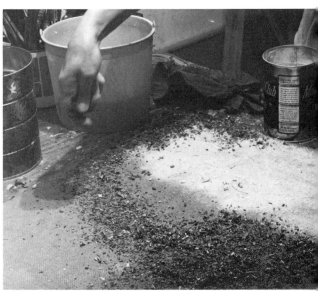

position entitled *Ennui,* with an attempt to achieve a relaxed, horizontal line. The linen refused to behave as she wanted, but when allowed to follow its own natural tendency became another thing: *Blithe Spirit,* a soaring, lyrical expression.

The dynamic lines of the molded fabric, solidified by the heavy absorption of PVA, so strongly implies something mysterious that, while the figures often seem leaden and heavy, they nevertheless appear to float. This effect is further enhanced by the use of color and surface (see Color Plates 26 and 27). Mrs. Todd's backgrounds are vaporous and smoky, an effect created by heavy scumbling of the paint and by an admixture of sawdust into the wet paint to granulate the surface. At times, a slightly greasy surface on the figures causes them to seemingly rise away from the duller surface of the background.

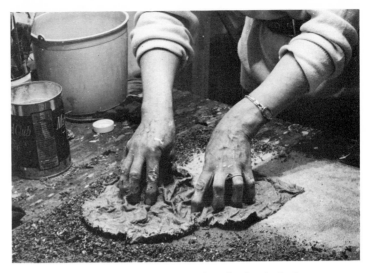

Fig. 75. When the support, with sawdust firmly stuck down, is dry, the glue-soaked fabric is removed from the solution and is placed on the surface of the support. It is then molded into the desired shape with the fingers, by crushing and squeezing.

Fig. 76. When thoroughly dry, the collage is ready to be painted. Oils or acrylics will work equally well. Thin paint, about the consistency of house paint, should be flowed on first, in large amounts, to penetrate the folds and cavities. After painting has begun, additional sawdust can be applied by sprinkling it on the wet surface, but if this is contemplated, it will be more convenient to use acrylic rather than oil paints. Under no circumstances should acrylics be used on top of oils.

Fig. 77. Final painting is best done with a relatively dry brush, using thick paint. Very strong dimensional effects are achieved by touching only the high surfaces of the folds and sawdust with this drier paint. By painting in several layers (scumbling light colors over dark ones and using transparent glazes) and by allowing the wrinkled fabric to determine the flow of the paint, rich opalescent effects are realized.

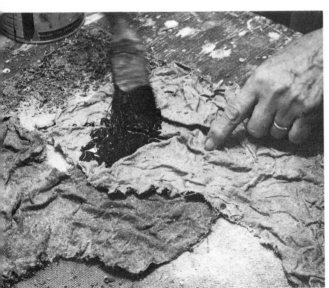

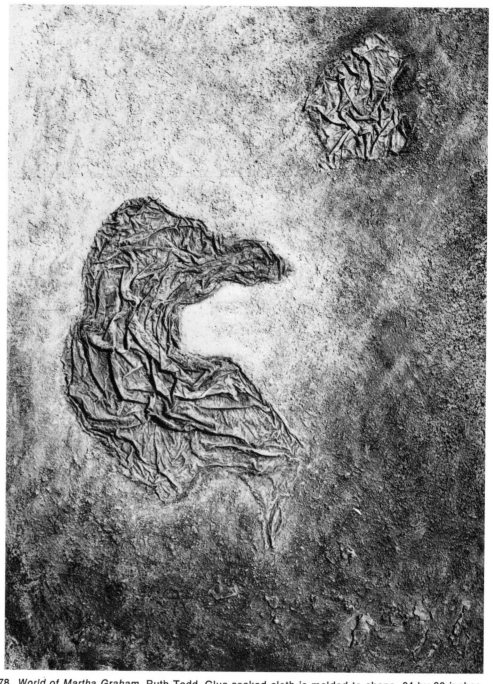

Fig. 78. *World of Martha Graham,* Ruth Todd. Glue-soaked cloth is molded to shape, 24 by 32 inches.

Fig. 79. (Opposite page) *Something There Is That Doesn't Like a Wall,* Ruth Todd. Sawdust-textured support with molded cloth figure and twine.

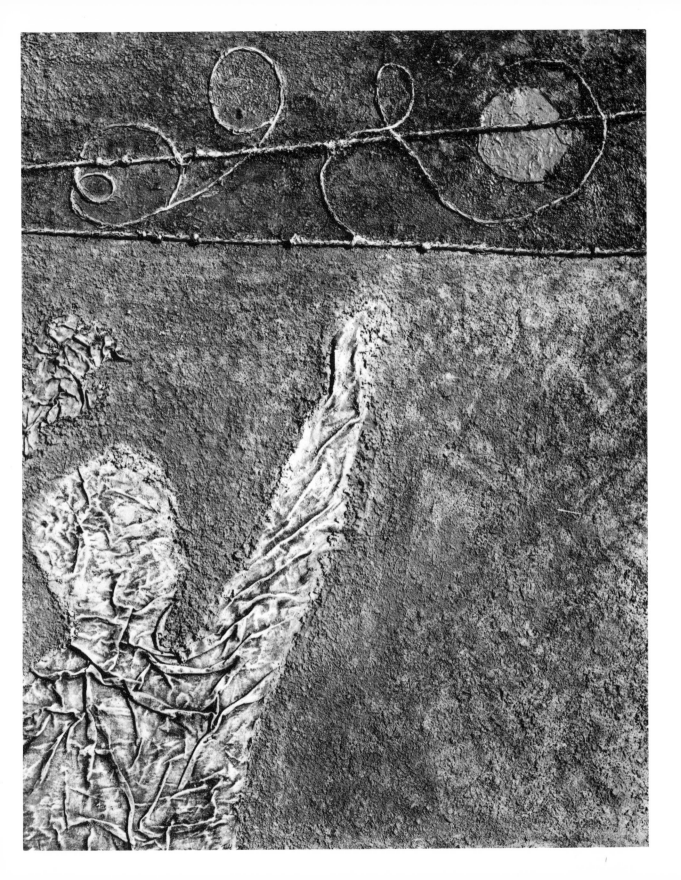

13. Exploring the Third Dimension

There are many ways of obtaining dimensional effects with paper as well as with fabric. Elevating the paper shapes from the background surface, for instance, also produces a raised sculptural effect. Although she works mostly in sculpture, artist Mirella Belshé from time to time turns out an interesting collage which shows the direct influence of third-dimensional thinking and may even make use of the same materials that appear in her sculpture.

In one of her projects for students, Mrs. Belshé asked for a design of a cube which could be folded and glued together from a flat sheet of cardboard. This cube was then die-cut on a printing press. Some of the resulting cardboard blanks, with the negative space of the unfolded cube cut from each flat sheet, became *The Five Cubes That Once Were* (Fig. 80 and Color Plate 29). Each of the blanks, its inner profile outlined in white, was painted in two colors and, when the five were assembled in layers, each was offset from the one below by a precise amount. The entire assemblage was mounted under glass. (If you happen to have access to a box factory, or to a printer who does die-cut work, similarly interesting blanks could be obtained for the asking.)

In another of Mrs. Belshé's collages, *Whale Watching* (Color Plate 28), a large sheet of aluminum-coated paper was used as a base. Overlaid on this base were nine equal rectangles of colored papers, each containing a negative cutout representing a whale in abstract form. The series of cutouts showed the whale in three stages of its evolutionary development. Each of these paper cutouts was then covered with a sheet of colored, transparent acetate related in color to the paper beneath. The entire collage is held together with narrow strips of cellophane tape.

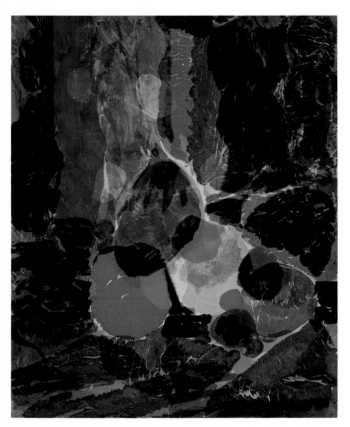

Color Plate 35. *Still Life,* Helen Colby. Dye transfer on X-ray film, 13 by 16 inches.

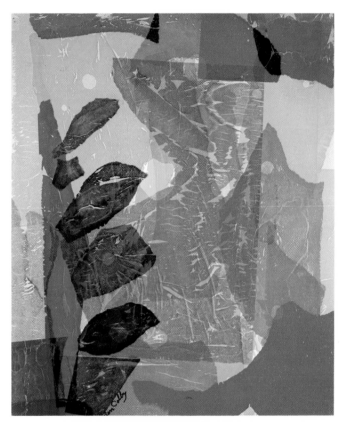

Color Plate 36. *Tropical Garden,* Helen Colby. Dye transfer on X-ray film, 13 by 16 inches.

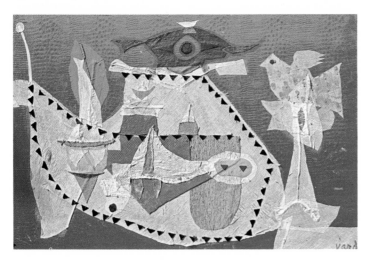

Color Plate 20. *Ship of Fools,* Jean Varda.
Textile collage, 20 by 36 inches. (Collection of Henry Miller.)

Color Plate 21. *The Eumenides,* Jean Varda. Textile collage, 30 by 50 inches. (Collection of Henry Miller.)

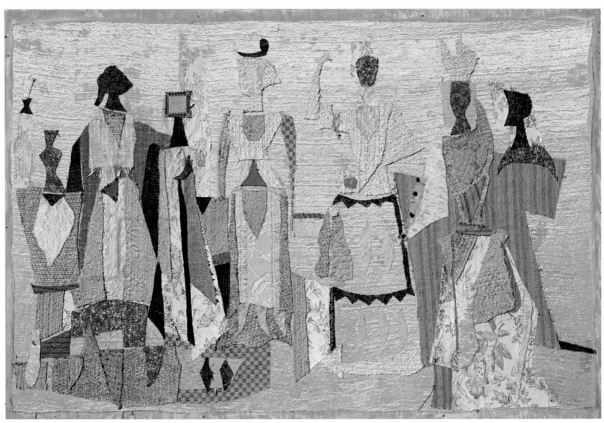

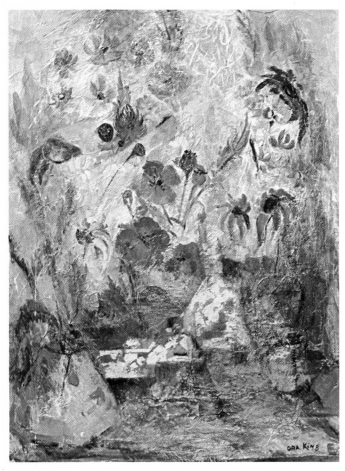

Color Plate 22. *Memories of a Garden,* Ora King.
Acrylic painting over rice-paper collage, 20 by 24 inches.

Color Plate 23. *Bent Chair,* Ora King.
Paper collage with acrylics, 14 by 16 inches.

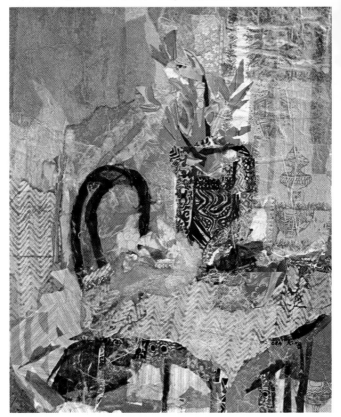

Color Plate 33. *Space Flight,* Helen Colby. Dye transfer on X-ray film, 13 by 16 inches.

Color Plate 34. *Townscape,* Helen Colby. Dye transfer on X-ray film, 13 by 16 inches.

Color Plate 31. *Two Cities on the River Po,* Irene Lagorio. Collage on canvas, with acrylic paint, 36 by 48 inches.

Color Plate 32. *Four Towers of the Poet,* Irene Lagorio. Collage on canvas with printed matter and acrylic paint, 60 by 60 inches.

Color Plate 24. *Cienega,* Ora King. Rice-paper collage provides a textured underpainting, 24 by 30 inches.

Color Plate 25. (Opposite page) *Still Life, Vase,* Ora King. Burlap collage with acrylic overpainting, 18 by 32 inches.

Color Plate 26. (Left) *First Experiment,* Ruth Todd.
Sawdust and cloth collage, 32 by 44 inches.

Color Plate 27. *Something There Is That Doesn't Like a Wall,* Ruth Todd.
Sawdust and cloth collage, 40 by 50 inches.

Color Plate 28. *Whale Watching*, Mirella Belshé. Aluminum-coated paper covered with cutouts of heavy, colored paper and overlaid with colored acetate, 20 by 25 inches.

Color Plate 29. *The Five Cubes That Once Were*, Mirella Belshé. Layered-cardboard collage, 11 by 14 inches.

Color Plate 30. *Holiday in Kitty's Castle*, Irene Lagorio. Collage on particle board, with embedded objects and acrylic paint, 15 by 36 inches.

Fig. 80. *The Five Cubes That Once Were,* Mirella Belshé. Thin cardboard with die-cut negative shapes were individually spray-painted and then stacked together, with each sheet offset to the right of the one beneath.

14. High Relief

The polyvinyl-acetate adhesive itself becomes a major visual element in the collages of Irene Lagorio. These fanciful creations, based upon medieval imagery, begin as fairly complete paintings with paper collage elements, which are then embellished with embedded objects often built into rather high relief. The adhesive is applied liberally in its undiluted form so that it forms deep masses, embedding a wide variety of crumpled foils, glass beads, coins, or other objects.

The work begins with sizing of the support. When minimal relief effects are contemplated, Ms. Lagorio chooses regular artist's canvas as the support. This is given a coating of rabbit-skin glue, followed by a coating of polymer gesso. Where heavy relief is to be used, ¾-inch particle board is chosen for the support, and this is given two coats of gesso made of rabbit-skin glue and whiting.

Upon either ground, the painting is done with acrylics and the collage elements are then superimposed on the dried painting, using PVA glue. Since the gesso, paint, and glue are all compatible when worked separately, the completed work is uniform in structure.

Painting on gesso surfaces is done with a series of thin acrylic glazes, the color being built up gradually and the several layers giving a greater feeling of depth and luminosity from within. When the paint has dried, the thinner collage elements of smooth foil and paper are pasted down with

Fig. 81. (Opposite page) *Four Towers of the Poet,* Irene Lagorio. Various printed matter (foreign currency and tickets of entry, and playing cards) was glued within the four tall shapes of the acrylic painting and heavy impasto was added on and around the collage elements with white acrylic paint. (See Color Plate 32.)

Fig. 82. (Below) *Lawyers' League,* Irene Lagorio. Acrylic painting was overlaid with paper foil shapes, which are in turn overlaid with bits of glass and crumpled balls of foil embedded in undiluted PVA. Completed collage on board is 4 by 12 inches.

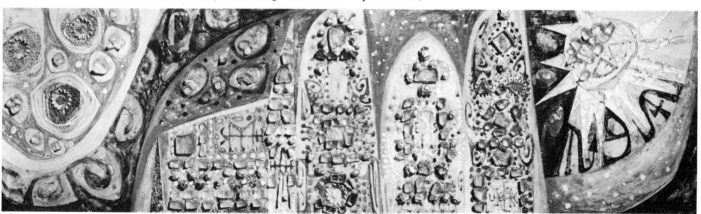

Fig. 83. *Scale Model Presentation for a Private Club,* Irene Lagorio. The model is 18 by 16 inches; the full-size collage is 5½ by 5 feet.

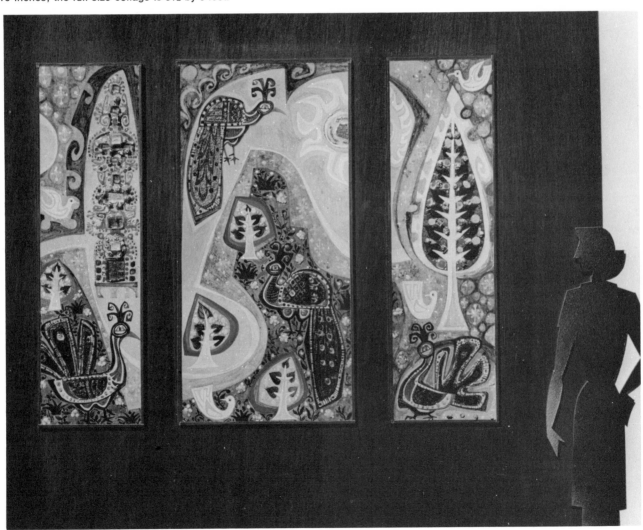

diluted PVA glue (the front surface of elements such as foil is not coated), and the heavier papers are presized when necessary. The three-dimensional objects are then added and undiluted PVA glue is flowed over each form, encasing it in the white emulsion. The milkiness of the polyvinylacetate emulsion disappears once the collage becomes thoroughly dry, though in heavy deposits of the glue this may require several days to accomplish.

After the work is completely dry, it is given a coat of damar varnish, which unifies the surface luster and increases the transparency of the work.

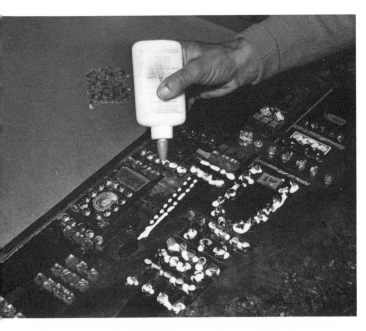

Fig. 84. (Above) Undiluted PVA glue is flowed over three-dimensional objects, embedding them as the glue dries. For completed collage, see Color Plate 30, *Holiday in Kitty's Castle.*

Fig. 85. (Right) Detail from *Fog on the Edge of the Lighthouse Tower* shows how milky glue emulsion dries to transparency.

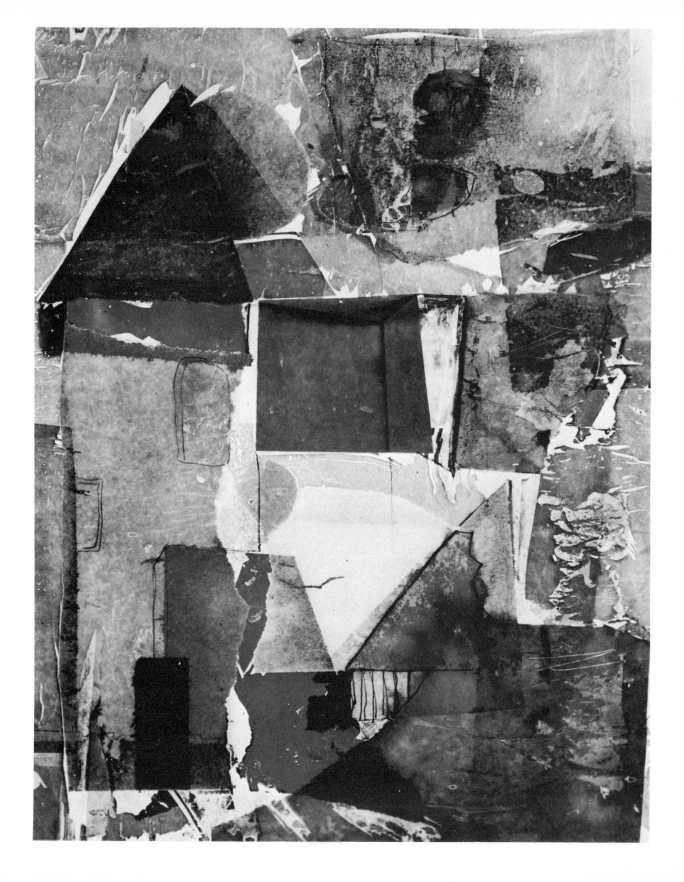

15. Film Collage: Stained-Glass Images

Combining collage techniques with photographic materials is another means of exploring two different visual arts. Helen Colby, while experimenting with some discarded X-ray films, developed an exciting new technique for transferring brilliant dyes onto the film base with all the control and many of the effects usual to collage.

The process depends upon the affinity of photographic gelatin emulsion for certain basic dyestuffs used in the coloring of tissue papers. A sheet of photographic or X-ray film becomes the support for the collage. Mrs. Colby uses films that have been exposed and developed; these must be bleached—that is, the black (metallic silver) images must be chemically removed. Large-size, previously used sheet films can be obtained from X-ray laboratories, hospitals, or commercial photographers. Often these will already have been bleached if the silver images have been removed for recycling. Otherwise it will be necessary to bleach them yourself. A simple formula for bleaching is as follows:

Stock Solution A

Potassium ferricyanide	1½ oz.	(40 grams)
Water	17 fl. oz.	(½ liter)

Stock Solution B

Sodium thiosulfate	17½ oz.	(500 grams)
Water	67½ fl. oz.	(2 liters)

For use, pour into a tray or container large enough to hold the film: 1 part of solution A, 4 parts of solution B, and 15 parts of water. Immerse the film until the emulsion is clear, then wash it in running water for at least 15 minutes. Do not mix the stock solutions until ready to use them, as they do not keep long after mixing. Discard the

Fig. 86. (Opposite page) *Townscape,* Helen Colby. Colors are transferred to clear film base by moistening tissue papers. Inked lines are added later.

diluted solution after use. Chemicals for these formulas are inexpensive and may be obtained at photographic dealers.

A very expensive alternative to using old, discarded film is to buy unexposed photographic film, which comes in sheets ranging up to 20 by 24 inches, although 8 by 10 inches is more commonly stocked. (Fresh X-ray films must be obtained through special suppliers.) These films must be prepared by removing all the light-sensitive material from the emulsion with photographic fixer. Dilute the fixer according to instructions on the package or bottle and immerse the film until the emulsion is clear. This need not be done in a dark-

Fig. 87. A sheet of clear X-ray film is laid on a piece of white illustration board (in the interests of visibility). Papers are torn and a trial assembly is made.

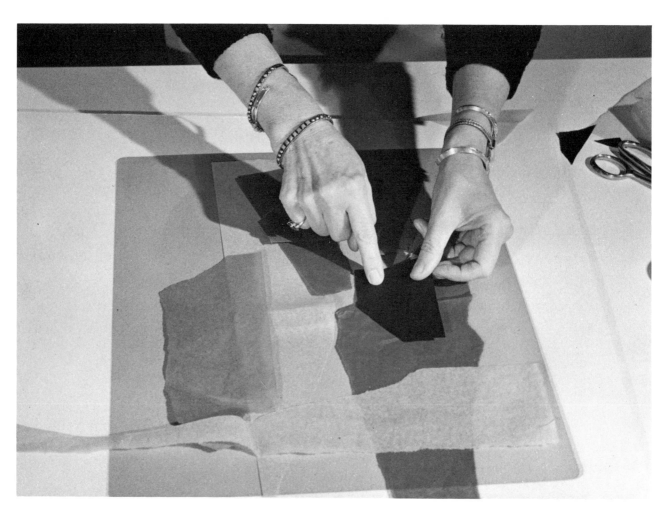

room and, as the film has not been developed, it is not necessary to bleach it.

The collage elements are derived from colored tissue papers containing basic dyes. Mrs. Colby has found several brands that work well, but especially recommends a brand called Crystal. The papers are cut or torn just as in Japanese rice-paper collage, and are arranged on the surface of the film. When a satisfactory arrangement is achieved, the paper elements are held in place with a finger or with some blunt object, such as the handle of a paintbrush, while water is applied with a brush to each element in turn (Figs. 87 to 90).

A great deal of the quality of the collage is de-

Fig. 88. A group of papers is moistened, using a 1-inch, sable watercolor brush. The composition is being held in place during this process with the handle of another brush. The sable brush is not heavy with water; rather it is kept fairly dry so that the water does not run beyond the lines laid out by the brush.

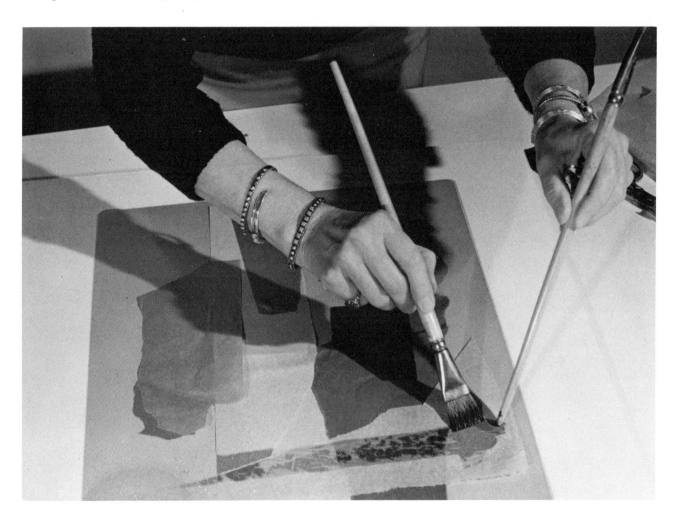

termined by the way in which the water is applied. The moment the paper becomes wet it expands and buckles, with parts of it adhering to the film base and other parts lifting off from it. In the spots where the paper has lifted, no dye is transferred, and the film remains clear underneath. Where two or more adhering, colored papers overlap, the resulting color is a mixture. And, by omitting water from certain spots, clear areas can be created. Many effects occur during this process, which gives the work a very special character. The number of successive transfers which can be superim-

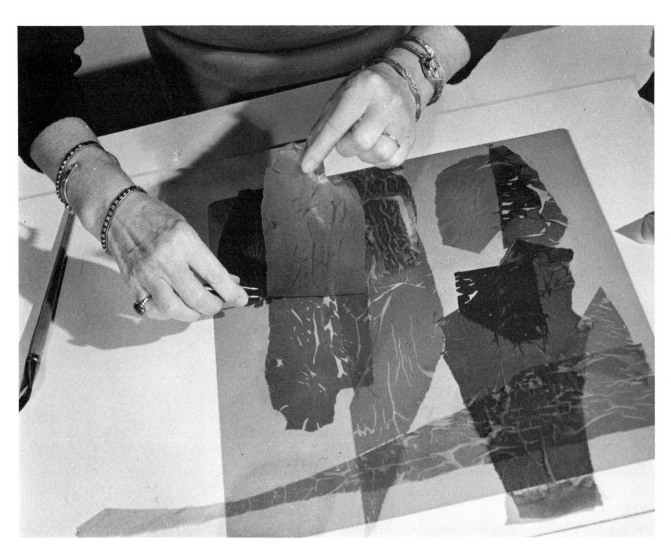

Fig. 89. After the damp tissue has remained in place for a minute or two, each piece is carefully lifted off with the fingers and a pair of tweezers.

posed is rather limited, however, and so color planning should take this into account.

The time that the papers remain in contact with the film base will influence the depth of color that is transferred. Most of the dye moves in a few seconds. When the color is deep enough, or at the maximum possible, the paper is stripped off. Since certain colors dye more deeply and some dye more rapidly than others, you might lift a corner of the tissue with a pair of tweezers to inspect the results, at least until you become more familiar with the process.

Fig. 90. On some compositions, India ink is added to create emphasis. The ink is applied either with a pen or a brush, and this should be done after the film has dried, unless some bleeding is desired.

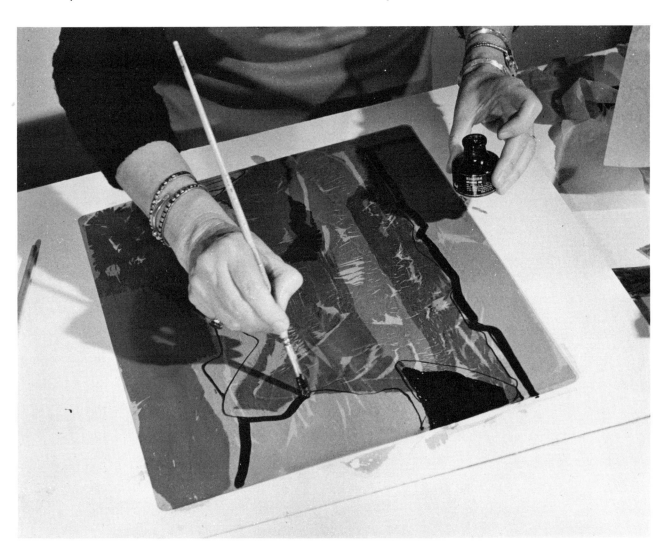

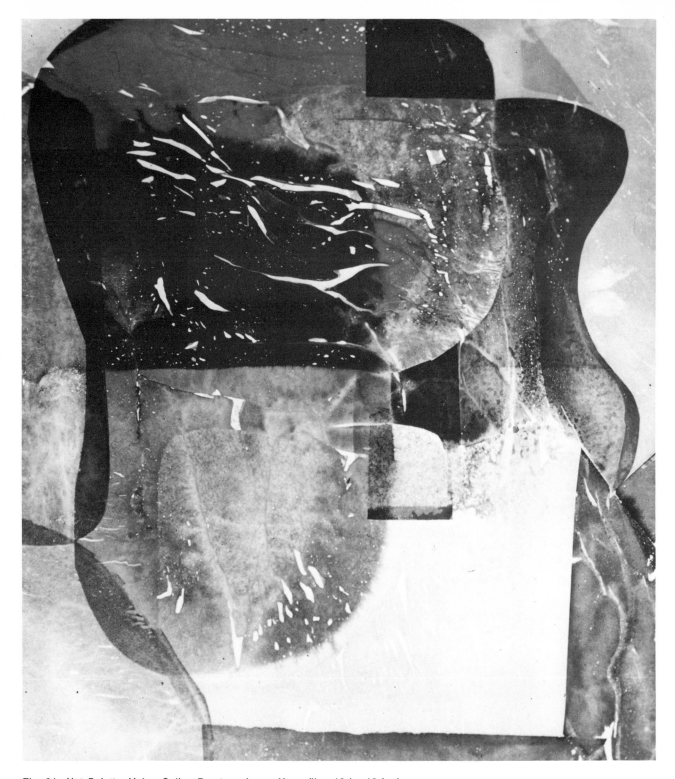

Fig. 91. *Hot Palette,* Helen Colby. Dye transfer on X-ray film, 13 by 16 inches.

Fig. 92. (Opposite page) *Carnival*, Helen Colby. Dye transfer on X-ray film, 13 by 16 inches.

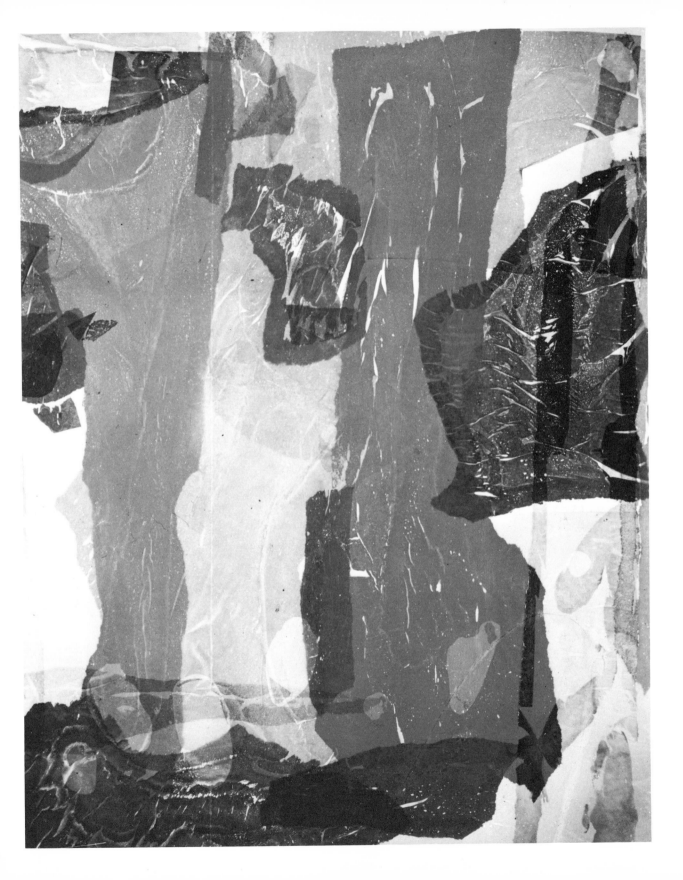

As soon as the film is dry, it may be mounted in a variety of ways. One method is to sandwich the film between two sheets of glass, one sheet being the non-reflective type (on the side from which the picture will be viewed). In *Townscape* (Fig. 86 and Color Plate 34), the film was held in place between the glass with two pieces of double-sided cellophane tape, which were cleverly worked into the composition. This method of mounting results in a "see-through" effect.

For a non-transparent but bright, intense effect, you might simply mount the film on a sheet of white illustration board, again using double-sided cellophane tape to anchor it in place.

A Collage Glossary

The first modern collages were made by Pablo Picasso and Georges Braque in Paris about 1912. This explains the French vocabulary on the subject.

Collage, meaning "glued together," has a colloquial meaning in French that must have delighted the Cubists who developed the art in a mood of iconoclasm: A collage is also an arrangement whereby a man and a woman live together without benefit of wedlock!

Affiches lacerés refers to one of the early techniques in collage in which fragments of posters and signs were "lacerated" or torn.

Brûlage is the process of burning or scorching.

Déchirage refers to papers torn rather than cut, and when done with wet paper the technique is called *déchirage mouillé.*

Décollage is the "undoing" of a collage; the term can refer to an effect achieved by lifting a pasted-down edge to create a three-dimensional relief.

Découpage is the cutting of papers or other materials with a scissors, knife, or blade rather than by tearing.

Froissage means the crushing or wrinkling of a collage material.

Objet trouvé is a "found object"—anything simply picked up and included in a composition just as it was found.

Papier collé is glued paper. In the very earliest collages, Picasso called his work *collage,* Braque called his *papier collé.* The distinction has become unimportant.